日本國即倭國在新羅國東南大海中依
山島居九百餘里專一沿海寇盜爲生中
國呼爲倭寇

TITLES IN THE SERIES

Series Editors, China Titles:
NIGEL CAMERON, SYLVIA FRASER-LU

Chinese Maps

IMAGES OF `ALL UNDER HEAVEN'

RICHARD J. SMITH

HONG KONG
OXFORD UNIVERSITY PRESS
OXFORD NEW YORK
1996

Oxford University Press

Oxford New York
Athens Auckland Bangkok Bombay
Calcutta Cape Town Dar es Salaam Delhi
Florence Hong Kong Istanbul Karachi
Kuala Lumpur Madras Madrid Melbourne
Mexico City Nairobi Paris Singapore
Taipei Tokyo Toronto

and associated companies in
Berlin Ibadan

Oxford is a trade mark of Oxford University Press

First published 1996
This impression (lowest digit)
1 3 5 7 9 10 8 6 4 2

Published in the United States
by Oxford University Press, New York

© Oxford University Press 1996

British Library Cataloguing in Publication Data
available

Library of Congress Cataloging-in-Publication Data
available

ISBN 0-19-585949-9

Printed in Hong Kong
Published by Oxford University Press (China) Ltd
18/F Warwick House, Taikoo Place, 979 King's Road,
Quarry Bay, Hong Kong

In Loving Memory of My Aunt,

Jean Livingston

Contents

Acknowledgements

Thanks above all to Cordell Yee, whose creative interdisciplinary scholarship, including invaluable contributions to the recent volume edited by J. B. Harley and David Woodward (see Selected Bibliography), has brought a new level of sophistication to the study of Chinese cartography. Thanks also to colleagues around the world—including Paul Canart, Ming Chan, Mark Elliott, Kathryn Engstrom, Gao Fan, John Henderson, Hsü Cho-yun, Li Xiaocong, Huang Yi-Long, Adam Y. C. Lui, Nathan Sivin, Sung Lung-fei, Helen Wallis, Mi Chü Wiens, Francis Wood, and David Woodward—for their help in providing concrete advice and in tracking down valuable resources.

I must also acknowledge my gratitude to the staff members, too numerous to name individually and unknown in some cases, of such useful libraries as those of Beijing University, the University of California at Berkeley, Columbia University, Harvard University, the University of Hawaii, Princeton University, and Stanford University, as well as other valuable archives, including the Beijing Central Library, the British Library, the Library of Congress, the Vatican Library, and the National Palace Museum in Taiwan. Finally, profound thanks, once again, to my wife, Lisa, who unfailingly makes my work, and my life, better than it ever could be without her.

1

Introduction

THIS IS A BOOK about Chinese perceptions of 'the other'. It focuses primarily on maps and related illustrations (known generically in Chinese as *tu*) as indices of evolving Chinese conceptions of 'barbarians'. Who were these 'barbaric' peoples? How were they and their living spaces defined? To what extent were barbarians distinguished from one another? How were they depicted in texts, maps, and other visual media over the course of Chinese history? In other words, what concrete images did the Chinese have in mind when they thought about foreign people and foreign places?

Some Basic Features of Traditional Chinese Cartography

Viewed from one standpoint, cartography in most societies is an objective 'science', whose history reveals a record of increasing technical competence measured by the avoidance of verifiable errors and motivated by an effort to improve our understanding of the physical world. Seen from another perspective, the history of cartography is the story of how maps can be used to claim, obtain, or exercise power, both domestically and internationally. From yet another point of view, maps are works of art (or, at least, craft productions), which reflect aesthetic concerns in a given society at a particular historical moment. Maps thus help us to gauge not simply the lands they purport to depict, but the attitudes and values of the society that produced them. With this point in mind we should be wary of trying to measure Chinese cartography by Western standards,

1

Chinese cartography is its own thing

an interpretive problem that has adversely affected the study of Chinese science as a whole for many decades.

From earliest times, maps in China have served a variety of military, administrative, ritualistic, and cosmological purposes. Although designed primarily as practical educational tools—to guide, instruct, and edify in times of both peace and war—they were also employed as a concrete means of asserting the emperor's territorial claims, whether local, empire-wide, or worldwide. Maps became symbolic tokens of exchange in China's domestic and foreign relations, and were even used to depict a perceived link between the realms of Heaven and Earth.

On the whole, Chinese map-makers tended to be broad-ranging scholars and artists rather than narrow technicians. Until the late nineteenth century there were no professional or specialist map-makers as such in China. For hundreds of years, all Chinese scholar–officials were expected to be able to produce maps, just as all were assumed to be able to execute beautiful calligraphy and to paint conventional landscapes. Occasionally, however, the government recognized the special cartographic skills of particular individuals and commissioned them to produce maps.

The scholars who created maps saw their productions as part of a larger intellectual and cultural enterprise embracing not only science (especially astronomy and geography) but also philosophy, art, literature, and religion (including divination). Since the realms of the physical and metaphysical lacked sharply defined boundaries in traditional times, Chinese cartography had a particularly imaginative bent as well as a profoundly humanistic purpose. In short, it invested physical space with deep, multivalent cultural meaning. As one result, certain powerful symbols, such as the Great Wall, might appear in Chinese maps even if they depicted times when the structure did not actually exist.

2

* viz. the inclusion of so many peoples from the 山海經 ?

One of the many distinctive features of Chinese cartography is its use of variable perspective. Generally speaking, traditional Chinese concepts of space emphasized a dynamism and fluidity that depended heavily on shifting vantage points and relativistic considerations of time. This attitude differed fundamentally from that of the West, where from about AD 1500 onward cartographers conceived of space as bounded, static, and therefore organizable and measurable. From a traditional Chinese standpoint no abstract geometrical system governed space; points within it could not, therefore, be defined or delineated in any absolute way.

As with traditional Chinese landscape paintings, which generally lack a single fixed point of reference in order to allow the viewer greater freedom in appreciating the scene, topographical maps often require the reader to change orientation as his or her eyes move across the surface. Thus, for example, although mountains might be drawn in elevation, rivers may well appear in plane. Chinese line maps, as well, often have a variable scale. The relative size of objects, and their distance from one another, are usually dictated not by their actual dimensions or by geometrical perspective but rather by the specific purposes for which the map is produced. Heavy annotation provides valuable information that might otherwise have been expressed by graphic images of scale.

Like certain kinds of Chinese paintings, Chinese maps often devote more space to the written text than to the actual image. Although the tendency for historians of cartography has been to denigrate heavily annotated maps in favour of more 'representational' ones, there is no intrinsic reason for doing so. It was not, after all, lack of skill or 'backwardness' that determined the nature of traditional Chinese cartography. In China, for reasons deeply rooted in the culture, texts rather than images remained the

primary source of representational authority for at least two thousand years.

A particularly striking feature of Chinese map-making is its emphasis on aesthetics—a function, perhaps, of the technologies of production shared by cartography, calligraphy, and painting. In contrast to the development of cartography in Europe, where manuscript maps became rather rare following the spread of copper engraving in the late fifteenth century, manuscript maps continued to predominate in China. Although the Chinese invented woodblock printing during the Tang dynasty (AD 618–907), and we can find striking examples of printed maps in China dating from as early as the twelfth century, until the twentieth century the majority of Chinese maps were produced with a brush. Many of these documents were shaded with a variety of colours and adorned with substantial amounts of calligraphy, sometimes even poetry.

In manuscript maps, and often hand-coloured printed maps as well, mountains and hills were generally rendered either blue, green, or brown (depending, apparently, on the density of vegetation), and rivers were brown, yellow, or light blue (depending, more or less, on depictions of silt content). Deserts could also be yellow or blue. Sometimes cartographers took the names of places literally: thus, the Huanghe (Yellow River) was often painted yellow, the Heilong Jiang (Black Dragon River), black, and the Yalu Jiang (Duck-green River), dark green. Some map-makers employed colours symbolically: areas in Mongolia might be rendered in black, reflecting a cosmology in which this colour denoted north (and the 'element' or 'agent' water), just as red signified south (and fire), green stood for east and wood, white indicated west and metal, and yellow symbolized centre and earth.

4

Yet another distinctive feature of Chinese maps is what Cordell Yee describes as their tendency toward introspection, a self-conscious preoccupation with concrete cultural and/or administrative concerns. <u>Overall, the Chinese have emphasized two primary features in their maps, especially domestic ones: inland waterways and walled cities</u> (or buildings). Both have tended to be exaggerated at the expense of other forms and figures, because each loomed so large in the minds of administratively oriented Chinese scholar–officials. A related 'distortion', which can also be explained in cultural terms, is the tendency to locate an administrative capital near the geometric centre of a map, as if to signify the ideal position of an unchallenged central government authority. Areas on the land frontier often show flag-poles to depict Chinese garrison stations—also symbols of imperial authority.

The sea, an object of fear to most Chinese, was often depicted with a threatening aspect, such as violent wave undulations and fierce splashes of surf. In sharp contrast to Western cartographers, long fascinated by distant waters as symbols of the exploration of the unknown, Chinese cartographers have devoted their primary attention to rivers and other inland waterways. Even maps of Chinese coastal waters reflect predominantly administrative concerns—in particular the suppression of smuggling and piracy. Significantly, however, these maps generally contain no hint of concrete trouble spots, an indication of the way in which Chinese cartography tended to reflect idealized political hopes and not simply geographical or administrative 'reality'.

Paradoxically, Chinese 'introspection' included looking outward. That is, one of the emperor's traditional 'domestic' concerns as the ruler of 'all under Heaven' (*Tianxia*)

was the management of foreign peoples—whether on the periphery of his realm or beyond. These 'barbarians' were, after all, at least theoretically the emperor's subjects. Thus, Chinese maps reflect a persistent concern with 'the other', and here, too, we find various forms of artistic idealization.

2

The Place of Barbarians in Chinese History

CHINESE SCHOLARS have long included accounts of foreigners (most often described generically as *yi*, 'barbarians') and foreign lands in their histories, encyclopaedias, and other compendia, both official and unofficial. From a practical standpoint, this information—ranging from local customs, agricultural and other products, and topography to military capabilities and economic activities—alerted the Chinese to external conditions that might affect the country's trade and security. From a more theoretical perspective, records of 'foreign countries' (*waiguo*) documented in detail a fundamental Chinese cultural conceit: the idea of China's superiority over all other peoples of the world.

Chinese Attitudes toward Barbarians

The sort of ethnocentrism suggested above is not, of course, unique to China, yet it had extraordinary power as a self-image because for much of its imperial history (from 221 BC to AD 1912) China possessed certain tokens of artistic, literary, and material culture that indeed surpassed those of the rest of the world. Foreigners became literally entranced by what one eighth-century Turkish text described as China's 'sweet speech and luxurious treasures'. For some two thousand years aliens petitioned to become Chinese subjects on the pretext that they had 'turned toward Chinese customs out of admiration' (*xiangmu Huafeng*). It is, therefore, no wonder the Chinese considered their country to be the Middle Kingdom (*Zhongguo*), the terrestrial focal point of 'all under Heaven' and the source of all civilization.

But who, exactly, were the 'barbarians'? To ask the question requires, first, a conception of 'Chineseness'. The following fourteenth-century definition of China provides one long-standing perception:

Central Cultural Florescence [*Zhonghua*] is another term for Middle Kingdom. When a people subjects itself to the Kingly Teachings [Confucianism] and subordinates itself to the Middle Kingdom, when in clothing it is dignified and decorous, and when its customs are marked by filial respect and brotherly submission, when conduct follows the accepted norms and the principle of righteousness, then one may call it [a part of the] Central Cultural Florescence.

Barbarians lacked these attributes. Consequently, they were commonly described by the Chinese in terms of metaphors drawn from the animal kingdom. Some seemed greedy, vicious, and vile 'like wolves'; others appeared to be stupidly submissive—more like dogs, sheep, horses, and cattle.

The orthodox view was, however, that people outside the pale of Chinese civilization could be culturally transformed or 'sinicized' by adopting the language, moral values, rituals, and other features of the self-styled Han people. The philosopher Mencius (372–289 BC) provided the classical conception for this process: 'Using [the culture of] the Xia dynasty [i.e., China] to transform the barbarians'. As the Tang scholar Chen Yan once remarked: 'Some people are born in barbarian lands but their actions are in harmony with rites and righteousness. In that case, they are barbarian in appearance but they have a Chinese heart and mind'.

Not all Chinese saw the matter this way, however. Some believed that biology and geography were destiny. The ancient work known as the *Zuozhuan* (Commentary of

Zuo) tells us, for instance, 'If a person is not of our kin, he is certain to have a different mind'. The famous Han dynasty commentator Zheng Xuan tells us:

<u>Broad valleys and great streams are variously formed, and the people living there have different customs.</u> With respect to hard and soft, light and heavy, slow and quick, they are differently tempered; [they enjoy] different blends of the five flavours; their implements and weapons are differently fashioned; different clothing is suitable for them.... The Chinese and the non-Chinese in the four quarters and the centre have their own characters which cannot be made to change.

From this standpoint, the 'cosmic breath' (*qi*) of a certain area determined whether its inhabitants lived like animals, 'in nests and caves', or embraced the civilizing attributes of 'ritual and righteousness'.

Of course, the Chinese naturally believed that their fortuitously situated 'middle ground' was particularly conducive to the production of sages and other worthies. It followed, then, that barbarous outsiders would gravitate to the Middle Kingdom in recognition of China's superior culture—and, of course, in hopes of their own cultural transformation. They would, in the stock Chinese phrase, 'come to be ruled' (*laihua*)(see Fig. 2.1). The *Zhongyong* (Doctrine of the Mean) puts the matter this way: 'By [the emperor's] indulgent treatment of men from afar, they will resort to him [literally 'return'] from the four quarters of the earth'. And the Confucian *Analects* tell us: 'If people from afar are not submissive, the influences of civil refinement and virtue must be cultivated in order to attract them'.

<u>This Sinocentric outlook made it possible to view foreign conquest itself as a matter of barbarians gravitating to China out of 'admiration for righteousness'.</u> And to the extent that foreign invaders such as the Mongols during

✳ very geography-based understanding of culture

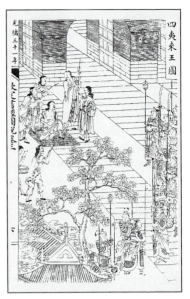

2.1 Barbarian envoys 'coming to be ruled', from *Qinding Shujing tushuo* (Imperially Endorsed Illustrations Based on the Classic of History; 1905).

the Yuan dynasty (1271–1368) and the Manchus during the Qing (1644–1911) self-consciously adopted Chinese culture as an administrative necessity, their behavior powerfully reinforced China's age-old conceit. As a group, in other words, these conquerers had 'turned toward [Chinese] civilization' (*xianghua*). 向華

We should not assume, however, that China's perception of foreign relations was ever entirely passive. Although the Confucian classics abound with pacific statements regarding the management of barbarians through cultural means, we can find many militant views in these same sources. The *Zuozhuan*, for instance, tells us: 'The Rong and Di [barbarians] know nothing of affection or friendship and are full of greed; the best plan is to attack them'. And Confucius himself is supposed to have commented: 'Distant people have nothing to do with our great land; ...wild tribes must

10

not be permitted to create disorder among the Chinese states'. Thus, strategic military concerns were never far from the minds of those who fashioned China's foreign policies.

Although China's early classics contained a great deal of interesting anecdotal information about foreigners, it was neither systematically organized nor strategically oriented. Only in the expansive and cosmopolitan Han dynasty (206 BC–AD 222) do we find coherent treatises on various foreign lands and peoples. The monumental *Shiji* (Historical Records) of Sima Qian (c. 145 BC–?), written in the early Han period, began the practice of including useful information on barbarians in all the official dynastic histories— 史記 a tradition that lasted from the later Han down to the Qing. Meanwhile, works on alien peoples by Han explorers such 漢代 as the legendary Zhang Qian, who travelled to Central Asia in the second century BC, inaugurated another long-standing tradition of strategic intelligence-gathering.

The Six Dynasties period (222–589), marked by repeated barbarian invasions of northern China and the pervasive penetration from India of Buddhism, at the time an alien belief system, contributed to a growing awareness of outside influences in the Middle Kingdom. But it was the glorious Tang dynasty, with its combination of aggressive military campaigns, religious pilgrimages to India, and vibrant 唐代 foreign trade, that brought Chinese interest in barbarians to unprecedented heights. During this period a great number of works on foreign lands were produced, most of which centred on South Asia (modern-day India) and the so-called Western Regions (*Xiyu*) of Central Asia.

The intellectual vitality of the Song dynasty (960–1279), together with the rapid expansion of printing and the explosive growth of maritime trade, brought another burst of Chinese writing about other countries. During this period

of extensive commercial penetration into South-East Asia and the 'south-western seas', most of the works written about barbarians naturally focused on countries accessible to maritime trade routes. They had very little impact, however, on Chinese attitudes. Whereas accounts of overland travel to India and Central Asia by Han and Tang dynasty explorers had generated a great deal of scholarly interest, self-absorbed Chinese literati of the Song period tended to treat narratives of foreign countries and peoples with utter contempt.

宋代

Chinese accounts of barbarians written during both the Jin (Ruzhen) occupation of northern China (1115–1279) and the Mongol (Yuan dynasty, 1279–1368) domination of the entire country, naturally emphasized China's Inner Asian frontier—the strategic area from which these two alien groups had invaded. But during the early years of the Ming dynasty (1368–1644), with the reassertion of native Chinese rule, another shift in orientation took place. The dynamic Yongle Emperor (r. 1403–24), anxious to reaffirm and even expand China's glorious reputation abroad, sent several great ocean expeditions westward under the leadership of a Muslim eunuch–admiral named Zheng He (1371–c.1433). Zheng's huge fleets, with more than three hundred vessels and nearly thirty thousand sailors, followed established Arab and Chinese trade routes all the way to India and the east coast of Africa.

The termination of Zheng's expeditions in 1433, provoked by the powerful opposition of Confucian scholars to 'wasteful' maritime adventures, signaled a precipitous decline in Chinese interest in people overseas. Ming China increasingly turned inward, preoccupied with the threat of barbarian invasion from the north. Fears of foreign conquest proved to be fully justified. In 1644, the Manchus invaded China from beyond the Great Wall and established the Qing

dynasty. Like the Mongols before them, the victorious Manchus paid primary attention to the Inner Asian frontier—at least until the nineteenth century, when Western imperialism occasioned a fundamental reorientation in strategic priorities.

The Chinese Tributary System

Central to China's self-image as well as its strategic vision was the so-called tributary system, which the Chinese considered to be an extension of the assumed political and social order of the early Zhou dynasty (c. 1100–256 BC). Outlined in classical works such as the *Yili* (Etiquette and Ritual), established during the Han dynasty, and highly developed by late imperial times, it rested on the assumption of a hierarchical structure of foreign relations, with China at both the top and centre. This system represented the ritualized affirmation of China's cultural hegemony over all other peoples. In this sense, the Middle Kingdom was, symbolically at least, an 'empire without neighbours'. Although never entirely successful, the Chinese tried whenever possible to assimilate their foreign relations to 'domestic' structures of power and authority (Fig. 2.2).

Tributary relationships rested on feudal principles of investiture and loyalty, with China as the lord and other states as the vassals. Non-Chinese rulers (and various groups of Chinese and foreigners under more direct Chinese rule) received a patent of appointment, noble rank, and an official seal for correspondence with the Chinese 'Son of Heaven'. They, in turn, as loyal subjects of the emperor, dated their communications by the Chinese calendar, came to court, presented their 'local products' as tribute, and performed all appropriate rituals of submission, including the

13

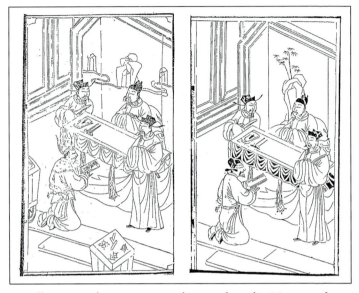

2.2 Illustrations from a Ming popular encyclopaedia, *Wanyong zheng-zong buqiuren quanshu* (The Complete Orthodox 'Ask No Questions' Handbook for General Use; 1609), highlighting the similarity between an official submitting a document to his superior (right) and a barbarian submitting tribute (left).

standard three kneelings and nine prostrations known as the kowtow. These loyal tributaries received imperial presents and protection in return and were often granted certain privileges of trade at the frontier and at the capital.

The tributary system, in addition to reinforcing Chinese cultural pretentions, provided an effective means of intelligence-gathering. Tributary states often presented maps to the throne as a sign of their submission to China, and regular interviews with tributary envoys helped the Chinese to gather valuable geographical information. A Tang source indicates, for example, that 'whenever foreign guests arrived [at the capital], the court...inquired about their country's

mountains and streams and its customs and terrain'. Of course, the tributary system also offered opportunities for foreigners to acquire strategic information about China. The Song scholar Shen Gua describes one such intelligence-gathering operation: 'During the Xining reign [1068–77], Korea sent tribute. In every province and country through which [the tributary mission] passed, they asked for maps, and in each case [maps] were made and presented. Mountains and rivers, thoroughfares and roads, the difficulty of the terrain—there was nothing that was not completely recorded'.

The tributary system underwent many permutations over time. Tributary regulations were repeatedly revised in response to changing Chinese conceptions of the 'outer' world. (Changing 'barbarian' conceptions of China also influenced the operation of the system, of course.) Certain technical terms and specific rituals likewise underwent modification as political conditions or social attitudes changed. Tributary relationships could also be modified. For example, 'external' vassals sometimes became 'internal' vassals and vice versa. New institutional structures might even arise, such as the *Lifanyuan* (usually translated, somewhat misleadingly, as the Court of Colonial Affairs) during the Manchu-controlled Qing dynasty. What remained constant was a highly refined vocabulary of imperial condescension that at once emphasized the inferiority and encouraged the loyalty of all China's tributaries, far and near.

In periods of military weakness, the Chinese were often obliged to buy off barbarians with tributary gifts and to make other compromises with the theoretical assumptions of the Chinese world order. In making peace with the foreign-ruled Jin dynasty in 1138, for instance, the founder of the Southern Song dynasty (1127–1279) had to accept the humiliating status of a vassal, reversing China's traditional relationship with barbarians. Instead of collecting 南宋

maps, the Chinese had to send maps to their enemies, in recognition of the unpleasant fact that China's boundaries had changed as a result of foreign invasion.

Even in periods of strength the tributary system proved to be remarkably flexible. Early in the Qing, for example, during the reign of the Kangxi Emperor (r. 1662–1723), Chinese authorities were able to make pragmatic decisions based on domestic politics and strategic interests. In 1793, the Qianlong Emperor (r. 1736–96) showed similar pragmatism in allowing Great Britain's special envoy, Lord Macartney, to have an imperial audience as a tributary—despite Macartney's refusal to perform the ritually required kowtow (Qing official documents recorded him as performing it nonetheless). From a Chinese perspective, the main consideration was that the aura of imperial authority over 'strangers from afar' had to be preserved.

The active participation of Europeans in the Chinese tributary system is a fascinating phenomenon, if only because the defining assumption of interstate relations in the West since the mid-seventeenth century—quite contrary to the viewpoint of the Chinese—had been that all nations were at least theoretically equal. Yet, well into the nineteenth century, as the scholarly work of J. J. L. Duyvendak, John Fairbank, and others demonstrates clearly, the Chinese managed to maintain the semblance of the traditional tributary system, even when dealing with Westerners. This was true not only in the rituals they required; it was also true in the literature they produced.

Images of Aliens

Although, as we have seen earlier, the Chinese had a long and rich tradition of describing foreigners, whether tribu-

taries, traders, or simple border barbarians, most of their written accounts contained no drawings of the people themselves. Textual descriptions seem to have sufficed in nearly all cases. There were, however, a few Chinese works that provided visual images of aliens, images that endured in China for many hundreds of years.

The earliest known illustrated account of barbarians in China is the *Shanhai jing* (Classic of Mountains and Seas; *c.* second century BC). We do not know, however, whether the first editions of the book contained pictures, or whether an early set of illustrations actually inspired composition of the written text. Some scholars believe that the *Shanhai jing* grew out of explanatory notes that accompanied a series of maps. In any case, by at least the third century AD there were illustrated editions of this popular text. The earliest extant printed version dates from the Song dynasty.

Although the *Shanhai jing* is based on a wide variety of historical, mythical, and even divinatory sources (including, perhaps, Greek, Middle Eastern, and Indian legends), a number of the topographical features mentioned in the book can be approximately identified. Moreover, some of the 'barbarian' peoples described in it have been linked to actual culture groups. The inhabitants of the 'Patterned Body Country', for instance, were most likely a tribe that practised tattooing—perhaps some group from the Kurile Islands off the eastern coast of Russia. Similarly, the 'Hairy People' described in the text may well be the Ainu of present-day Japan.

On the other hand, many of the descriptions of 'human beings' in the *Shanhai jing* seem quite fantastic (Fig. 2.3). We find, for example, in the southern reaches of the world the land of the Huantou, who have human bodies and faces but bird-like wings and beaks; a country where people are carried by poles through their perforated chests; and areas

17

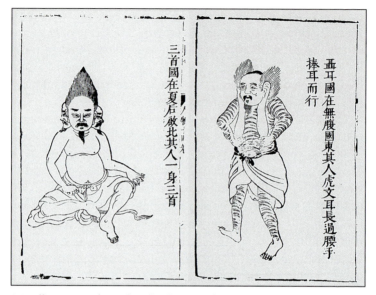

2.3 Illustrations from the *Shanhai jing* showing a person from the Land of People with Three Heads (left) and a person from the Land of People with Pendulous Ears (right). Reproduced in the *Sancai tuhui*.

populated respectively by folks with crossed legs, particularly long arms, and three heads. There are also accounts of a place inhabited entirely by 'small people' only a few inches tall, and yet another with black-skinned 'immortals'. In the far west is Xuanyuan Land, where a short life is eight hundred years and the beings have human faces but the bodies of snakes. We also encounter in this region various individual countries comprised of 'white people', people with three bodies, people with just one arm, and those with especially long legs. To the north are states with people who have only one hand and one foot, and others with elongated ears, or no bowels, or only one eye. To the east are two-headed people, 'big people', and a land of gentlemen—the last described as individuals who are

18

polite and always accompanied by two tigers.

Despite early criticisms by the Han historian Sima Qian, the *Shanhai jing* stood for some two thousand years as a major Chinese source of information on foreigners. Indeed, some of the written accounts of barbarians discussed in the previous section seem to have drawn directly upon it. Moreover, as we shall see shortly, the *Shanhai jing* provided many textual descriptions and illustrations for Chinese encyclopaedias and almanacs in late imperial times. One reason may be that scientifically minded Chinese intellectuals continued to see merit in the work. The distinguished Qing dynasty scholar Ruan Yuan, for instance, considered the *Shanhai jing* to be 'an ancient geography book containing practical help for worthy projects, and not just fabulous talk'.

Another genre of books depicting foreigners came to be known as 'illustrations of tribute-bearing peoples' (*zhigong tu*). These works, based at least in part on actual observation, bore such titles as *Xiyu zhuguo fengwu tu* (Illustrations of the Customs and Products of All the Countries in the Western Regions; AD seventh century), *Jiaxiasi chaogong tuzhuan* (An Illustrated Account of the Tribute-bearing Kirghiz People; 844), *Huayi lieguo rugong tu* (Illustrations of Sino-foreign Tribute-bearers; no date), *Xuanhe fengshi Gaoli tujing* (An Illustrated Record of an Embassy to Korea in the Xuanhe Period; 1124), and *Yiyu tuzhi* (An Illustrated Gazetteer of Foreign Lands; c. 1430).

The most comprehensive illustrated account of tributary peoples in imperial times was the massive official compendium entitled *Huang Qing zhigong tu* (Illustrations of the Tribute-bearing People of the Qing; 1761)(Fig. 2.4). The preface to this work indicates that it was compiled during the 1750s with the intent to show how 'within and without the empire united under our dynasty, the barbarian

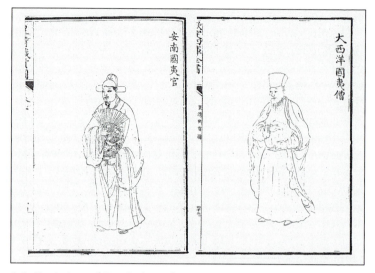

2.4 Depictions of People from the *Huang Qing zhigong tu* showing an 'Annamese barbarian official' (left) and a 'barbarian cleric' from the Great Western Ocean (right).

tribes submit their allegiance and turn toward civilization'. Most of the ten volumes deal with the peoples of Inner Asia and the ethnic minorities of South-West China. The first, however, focuses on China's overseas tributaries, listed in the standard order: Korea, the Liuqiu Islands, Annam, Siam, Sulu, Laos, Burma, and the Great Western Ocean (Da Xiyang). These discussions are followed by sections on the Small Western Ocean (Xiao Xiyang), England, France, Sweden, Holland, Russia, and the Philippines.

The entries on the West display a great deal of geographical confusion, despite many decades of direct contact with European informants. The so-called Great Western Ocean Country, for example, is located vaguely in the Atlantic region but identified both with Italy and Portugal. Other Western nations, including England, France, Sweden,

✳ Some kind of cultural blindness toward white people / Westerners

Holland, and Russia are indiscriminately lumped together with Asian countries such as Japan, Borneo, Cambodia, Java, and Sumatra. Modern France is confused with Ming dynasty Portugal; England and Sweden are recorded as countries dependent on Holland. In religious matters the *Huang Qing zhigong tu* tells us that Portugal/France was a Buddhist country before its people accepted Catholicism.

Textual descriptions of foreigners in the *Huang Qing zhigong tu* tend to be categorical. Thus we read that the skin of Westerners is 'dazzling white', and that their noses are 'lofty'. Their custom, we discover, is 'to esteem women and think lightly of men'. Males, for their part, are characterized as 'violent', 'tyrannical', and 'skilled in the use of weapons': 'They wear short coats and tip their black felt hats as a sign of politeness'. Swedes and Englishmen 'like to take snuff, which they carry in little containers made of golden thread'. The people of Hungary 'ride on horseback, educate their women, and are rich in natural resources'.

The superficiality and confusion of these accounts suggests the profound lack of interest in the West the Chinese had prior to the Opium War of 1839–42. The inclusion of so many European countries in the *Huang Qing zhigong tu* probably indicates nothing more than a general desire to show how vast was China's network of 'loyal' tributaries. Similarly, the inclusion of substantial illustrated sections on barbarians in Ming and Qing encyclopaedias and almanacs seems to have been motivated primarily by a desire to appear as comprehensive as possible, not by a sense that foreigners were intrinsically worthy of special attention. Significantly, all of these works are marked by the same sort of superficial content and general confusion evident in the *Huang Qing zhigong tu*.

Part of the confusion may stem from a tendency in certain kinds of Chinese compendia—élite as well as popu-

lar—to place materials from many different sources side by side, without systematic evaluation. Even standard reference works, such as the Ming encyclopaedia *Sancai tuhui* (Illustrated Compilation of the Three Powers [Heaven, Earth, and Man]; *c.* 1607) and the monumental Qing encyclopaedia *Gujin tushu jicheng* (Collection of Illustrations and Writings, Ancient and Recent, 1725), display this tendency. Each employs drawings from the *Shanhai jing* to represent barbarian peoples from various parts of the world, and neither differentiates clearly between the depictions of actual culture groups, derived from works such as the *Yiyu tuzhi* or *Huang Qing zhigong tu*, and mythical peoples drawn from the *Shanhai jing*.

The same is true of more 'popular' Ming and Qing encyclopaedias, such as the *Wanbao quanshu* (Complete Book of a Myriad Treasures), and the *Wanyong zhengzong buqiuren quanshu* (The Complete Orthodox 'Ask No Questions' Handbook for General Use). Editions of both these works circulated in China for about three hundred years, and here, too, folks from 'The Land of People with Perforated Chests', 'The Land of People with Crossed Legs', 'The Land of People with Three Heads', and 'The Land of People with One Eye' appear alongside rather conventional depictions of the Japanese, Koreans, Liuqiu Islanders, Vietnamese, Turks, and others. This predisposition to conflate 'factual' and more 'fanciful' material on barbarians is also evident in certain collections of Chinese maps.

Blend of fact & fiction in Chinese maps and encyclopaedias

3

The World in the Chinese Cartographic Tradition

TRADITIONAL CHINESE MAPS reflected the Sinocentric principles of the Chinese world order, in which China was internal, large, and paramount and other countries were external, small, and subordinate. In keeping with this principle, China occupied the centre of most renderings of cartographic space. The size and shape of 'the world' might vary according to changing perceptions of China's relationship to barbarians, but tributary relationships were never far from the minds of Chinese cartographers. Indeed, texts accompanying maps of the outside world often refer to the frequency of tributary missions by various foreign peoples, and sometimes inscriptions of this sort appear directly on the map.

Early Chinese Maps of the World

The *locus classicus* for Chinese graphic accounts of 'the world', dating from about the sixth century BC, was the 'Tribute of Yu' (*Yugong*), a chapter of the *Shujing* (Classic of History). This enormously influential document ennumerates the traditional nine provincial areas of China and their characteristic products. It also describes five major concentric geographical zones emanating outward from the capital: royal domains, princely domains, a pacification zone, the zone of allied barbarians, and the zone of savagery. At the outer limits of this structure, the borders are 5,000 *li* (about 1,700 miles) long. Although the *Shujing*

禹貢
in
書經

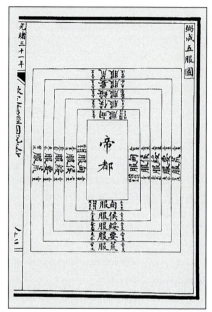

3.1 The *Yugong* diagram, reproduced in *Qinding Shujing tushuo*.

gives no indication of the shape of these zones, they have been depicted conventionally as rectangular, following the cosmological notion of a 'square' earth (Fig. 3.1). Similar stylized depictions appear in Han dynasty works such as the *Zhouli* (Rituals of Zhou) and the *Liji* (Record of Ritual). Such representations of terrestrial space, like those cast on Han dynasty bronze 'cosmic mirrors', reinforced the common Chinese belief that the earth was square and flat.

Three major conceptions of the relationship between Heaven and Earth existed during the latter part of the Han dynasty, and none of these was inconsistent with a view of the earth as square. The *gaitian* (covered heaven) theory posited the earth as a square-shaped bowl, turned upside down and covered by a hemispherical dome. The heavens were said to be 'round, like an umbrella', while the earth

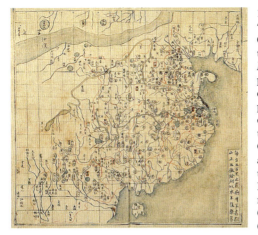

1. A hand-drawn 'General Map [of the Chinese Empire]' from the *Da Ming Guangyu kao*, focusing on China proper and indicating only in small calligraphy Korea to the northeast and Annam toward the south. The Gobi Desert appears as a band of blue at the top of the map. Reproduced with permission from the Oriental and India Office, British Library.

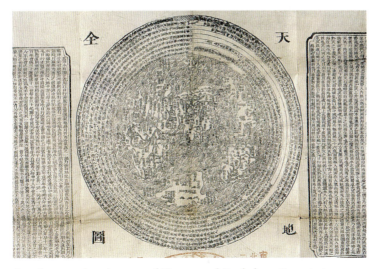

2. A comprehensive map of Heaven and Earth from *Sancai yiguan tu*. Reproduced with permission from the Oriental and India Office, British Library.

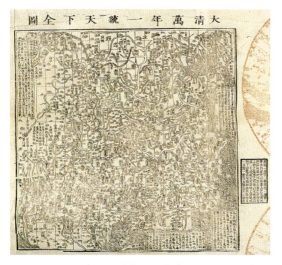

3. A perpetual map of the unified Qing empire, from *Sancai yiguan tu*. Reproduced with permission from the Oriental and India Office, British Library.

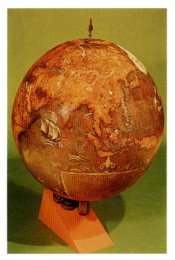

4. The Longobardi–Diaz globe of 1623. Reproduced with permission from the Map Room, British Library.

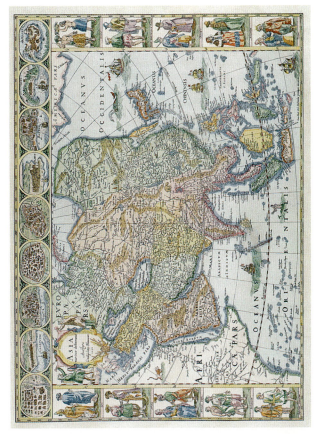

5. A Dutch map of Asia, dated 1639, by Guiljelmo Blaeuw, showing the territory from the Mediterranean to Japan. China appears as an amorphous green land mass occupying almost the entire east coast of Asia. The ovals at the top of the map depict various cities, from Goa to Macao, while the rectangles in the columns on the right and left sides portray various foreign people, including Syrians, Arabs, Javanese, Chinese (third from the bottom on the right side), and Russians. Just as the faces of Westerners in the *Huang Qing zhigong tu* look 'Chinese', so the Chinese faces in this Dutch map of Asia look 'Western'. From the author's collection.

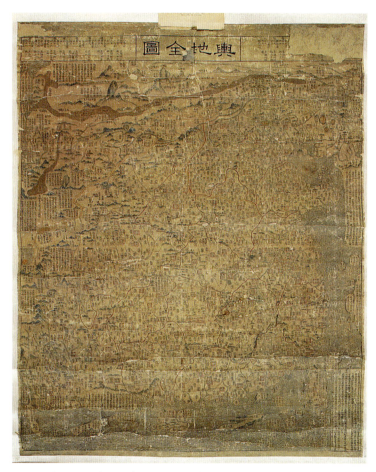

6. *Yudi quantu* (Complete Terrestrial Map; 1673). Reproduced with permission from the Geography and Map Division, Library of Congress.

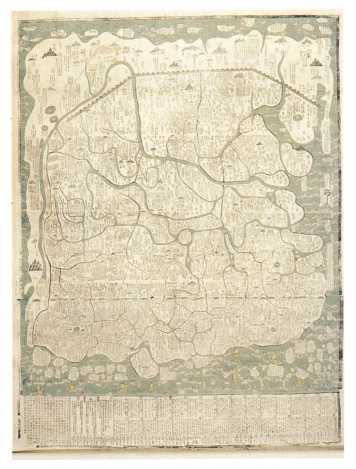

7. Full view of an untitled world map of 1743. This anonymous
map is a particularly beautiful example of Song-style cartography in
the tradition of the *Huayi tu*. Reproduced with permission from the
Oriental and India Office, British Library.

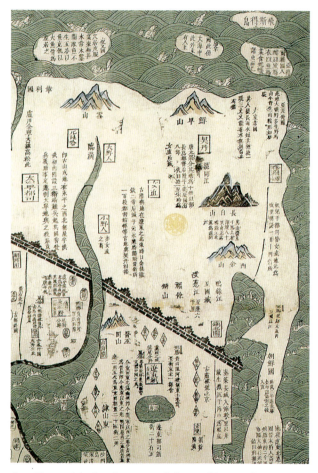

8. Upper right-hand portion of the world map of 1743. Here, the Great Wall appears prominently as it crosses the Liaodong peninsula and seems to stop just before intersecting with Korea. Reproduced with permission from the Oriental and India Office, British Library.

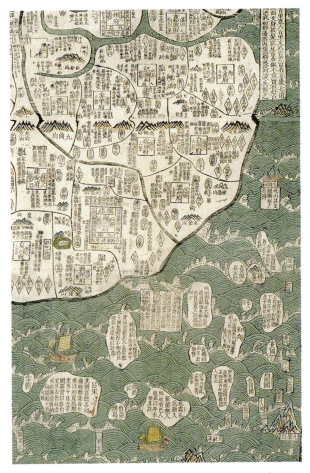

9. Lower right-hand portion of the world map of 1743. Luzon and the Liuqiu Islands lie almost side-by-side in the south-west corner of this section. There are also several mythical countries from the *Shanhai jing* scattered about. The threatening aspect of the sea is especially noticeable in the southern seas. Reproduced with permission from the Oriental and India Office, British Library.

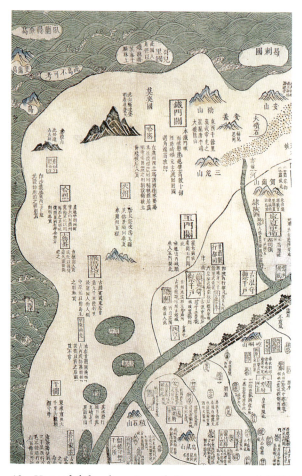

10. Upper left-hand portion of the world map of 1743. Most of this corner of the map identifies Chinese territory historically associated with the 'Western Regions'. The Jade Gate Pass appears prominently in the middle, well above the end of the Great Wall. The 'Great Western Ocean [Country]', usually identified with Italy and/or Portugal, is represented by a small square off the western coast. Reproduced with permission from the Oriental and India Office, British Library.

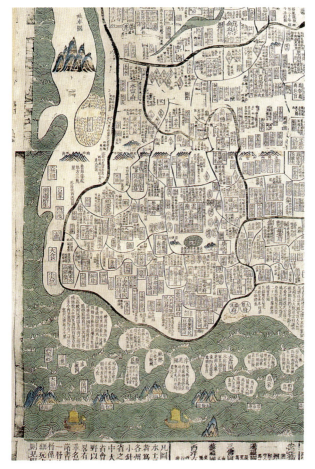

11. Lower left-hand portion of the world map of 1743. This section of the map focuses on South-West China (principally Yunnan province), with a thin strip of land to the far west that contains rectangles with the names of various countries such as India and Arabia. One rectangle conspicuously marks the spot 'where Buddhism arose'. Reproduced with permission from the Oriental and India Office, British Library.

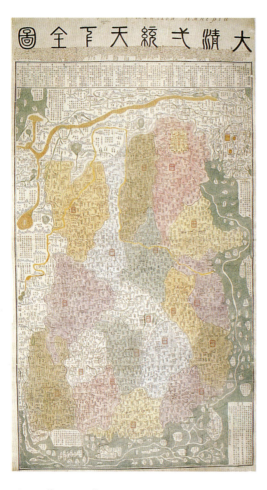

12. Full view of *Da Qing yitong tianxia quantu* (The Great Qing Dynasty's Complete Map of All under Heaven; 1819), which shows America and various other Western countries as islands along the borders of the main land mass. Reproduced with permission from the Map Room, British Library.

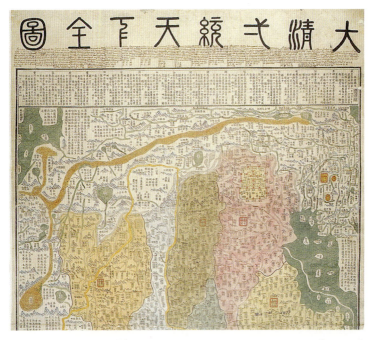

13. Upper portion of *Da Qing yitong tianxia quantu*. A substantial amount of Russian-language commentary has been added to this map. Reproduced with permission from the Map Room, British Library.

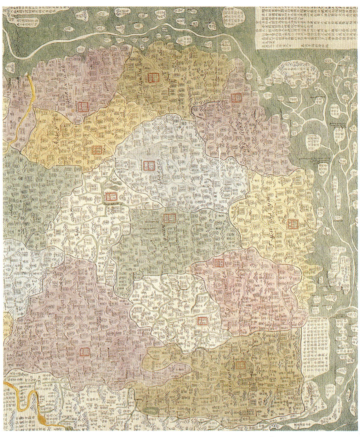

14. Lower portion of *Da Qing yitong tianxia quantu*. Here, in the south-west corner, the Indian Ocean is identified as the 'Small Western Sea'. Once again we see countries described in the *Shanhai jing* (and other such sources) scattered about the map. Reproduced with permission from the Map Room, British Library.

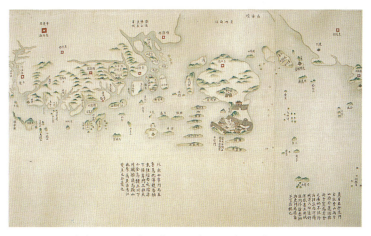

15. A map of the eastern hemisphere, from the *Haijiang yangjie xing-shi quantu*. Reproduced with permission from the Map Room, British Library.

16. A map of the Guangzhou (Canton) area, from the *Haijiang yangjie xingshi quantu*. Reproduced with permission from the Map Room, British Library.

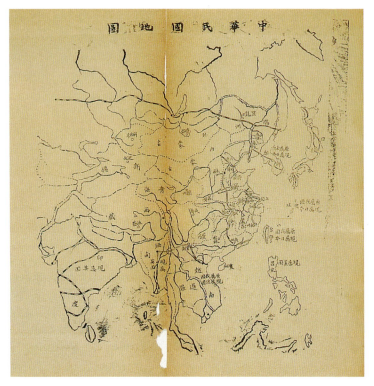

17. A map of Asia, from *Zhonghua minguo yuannian lishu* (Almanac for the First Year of the Republic of China; 1912). The commentaries written on this map not only point out the many places taken away from China by various imperialist powers; they also identify other areas in Asia, such as India, that fell to foreign aggression. Reproduced with permission from the Oriental and India Office, British Library.

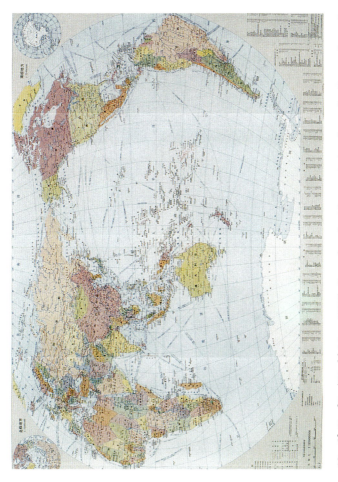

18. *Shijie ditu* (World Map; 1990). Reproduced with permission from the Geography and Map Division, Library of Congress.

儿童地图册

ERTONG DITUCE

（世界部分）

中国地图出版社

19. A children's map book, from the series *Ertong ditu ce*. This small volume, designed for educational use by both 'household heads and elementary school teachers', assists children in reading maps and provides them with information about the 'racial groups', oceans, land-forms, products, historical monuments, flora and fauna, and flags of the world. Of the ten great ancient monuments identified in it, including the Pyramids of Egypt, the Leaning Tower of Pisa, the Taj Mahal, the Cathedral of Notre Dame, the Parthenon, and so forth, China claims two: the Forbidden City and the terracotta tomb guardians of the First Emperor.

was described as 'square, like a chessboard'. The *huntian* (enveloping heaven) system viewed the heavens metaphorically as an egg enveloping its yoke (not necessarily spherical, although sometimes described as 'round, like a crossbow bullet'), while in the *xuanye* (empty space) conception, the sun, the moon, the stars, and the earth floated freely in a void. For most of China's imperial history, the official historians of each dynasty consided the *huntian* conception to be the correct one, but Chinese maps continued to reflect the basic idea of a square or rectangular plane, with little or no account taken of the earth's curved surface.

The grandeur, expansionism, and cosmopolitan spirit of the Han period encouraged an interest in maps of both the Chinese empire and the larger world. Thus, for example, when Zhang Qian returned from his famous journeys to Central Asia in 126 BC, Emperor Wu consulted 'ancient maps and books' in order to locate some of the far-off places to which the intrepid merchant–ambassador had travelled. And in 99 BC, the great Han general Li Ling composed maps for the emperor of areas as far as a thirty day's journey north of the Chinese frontier. About sixty years later, Emperor Yuan received an illustrated account of the Xiongnu people (precursors of the Huns), which probably contained maps. Similar works were created for emperors of the later Han, particularly as the foreign menace mounted on China's northern frontier.

During the Six Dynasties period, Pei Xiu, Minister of Works for the alien Western Jin dynasty (265–317), brought Chinese cartography to a new stage of development. Highly critical of Han-period maps for failing to reflect 'observed reality', Pei developed six principles of map-making which had an enduring influence in China: 1) proportional measure or graduated divisions (*fenlü*), the determination of

漢代

map scale; 2) regulated view (*zhunwang*), the depiction of the correct relationship between the different parts of a given map; 3) road measurement (*daoli*), a way of fixing distances based on triangulation; 4) levelling (or lowering) of heights (*gaoxia*), presumably a system of ground measurement; 5) determination of diagonal distance (*fangxie*), to be used in depicting mountains and rivers; and 6) straightening of curves (*yuzhi*), apparently a measuring technique for undulating surfaces.

Among Pei's most renowned cartographic creations was a work known as the *Fangzhang tu* (One-*zhang*-square Map; a *zhang* is approximately three yards long), no longer extant. According to Tang dynasty sources, this map was a scaled-down version of an 'old great map of the world', originally drawn on some eighty bolts of silk. Reportedly drawn to scale (1:1,800,000), the *Fangzhang tu* made it possible for China's rulers to 'comprehend the four corners of the world' without ever having to leave their imperial quarters. We do not know, however, whether Pei Xiu simply redrew the old map or modified it based on textual sources.

The foremost map-maker of the Sui and Tang periods was the eighth-century scholar, Jia Dan. He is particularly well known for making explicit one of Pei Xiu's implicit assumptions—that written texts are a valuable complement to any map. In Jia's words: '[When depicting things such as] mountains and rivers, one must talk of heads and tails and sources and reaches. On a map, these things cannot be completely drawn; for reliability, [therefore,] one must depend on [appended] notes.'

Although, as with Pei Xiu, no extant map can be traced directly to Jia, he may well be responsible for inspiring one of the most famous works in the Chinese cartographic tradition: the *Huayi tu* (Map of China and the Barbarians). This anonymously created and extraordinarily detailed map

26

<u>of the known world, about three feet by three feet and care-</u>
<u>fully engraved on a stone stele in 1136, supplies a total of</u>
<u>about 500 place-names</u>. It also identifies thirteen rivers and
major tributaries, four major lakes, and ten mountain ranges.
Information about foreign lands appears in the form of sub-
stantial written notes arranged along the margins of the
map (Fig. 3.2).

3.2 The *Huayi tu*, from Joseph Needham, *Science and
Civilization in China*, vol. 3. Reproduced with permission
from the Needham Research Institute and the Cambridge
University Press.

According to one of the many inscriptions on the *Huayi
tu*, it records only the most familiar names from among
the 'several hundred countries' listed by Jia Dan on his
own world map. Presumably the map referred to is the
Hainei Huayi tu (Map of Chinese and Barbarian Lands with-
in the [Four] Seas; no date), which Jia reportedly 'ordered

an artisan to paint...on a scroll'. The *Jiu Tangshu* (Old Tang History) tells us that this map 'was three *zhang* wide, and three *zhang* and three *chi* [a Chinese 'foot'] high. Its scale was one *cun* [a Chinese 'inch'] to one hundred *li*.' Although the Song dynasty *Huayi tu* lacks this sort of expressed scale, the map itself may well have been provoked by Jia's monumental work.

Most other extant Song dynasty 'world maps' bear a close resemblance to the *Huayi tu*, as a recently discovered twelfth-century collection, the *Songben lidai dili zhizhang tu* (Song Dynasty Edition of Handy Geographical Maps, Chronologically Organized; reprinted in 1989) indicates clearly. Although not as comprehensively annotated as the *Huayi tu*, the maps in this collection reveal similar configurations of both coastline and interior space.

Of course, not all Song dynasty world maps arose from the same source. Indeed, inscribed on the reverse side of the *Huayi tu* of 1136 is an astonishingly 'modern' looking version of the *Yuji tu* (Map of the Tracks of Yu)(Fig. 3.3)

3.3 The *Yuji tu*, from Joseph Needham, *Science and Civilization in China*, vol. 3. Reproduced with permission from the Needham Research Institute and the Cambridge University Press.

that marks the first known use of the so-called 'lattice-work' cartographic grid in China. A side of each square represents 100 *li* (*c.* 33 miles), yielding a scale of about 1:1,500,000. The outstanding feature of this map is the 'accuracy' of its depiction of major landforms. The representation of China's coastline, for instance, looks remarkably like modern twentieth-century renderings, prompting Joseph Needham to write: 'Anyone who compares this map with the contemporary productions of European religious cosmography...cannot but be amazed at the extent to which Chinese geography was at that time ahead of the West.'

World Maps in Late Imperial Times

Most subsequent Chinese cartographers favoured maps that did not indicate mathematical scale by graphic means, with a few significant exceptions. During the Yuan dynasty, when Islamic cartographic influences penetrated China, two 元代 major 'world maps' were produced by Chinese scholars: one, Zhu Siben's *Yutu* (Terrestrial Map; *c.* 1320), employed the grid system; the other, Li Zemin's *Shengjiao guangbei tu* (Map of the Vast Reach of [China's Moral] Teaching; *c.* 1330), did not. According to some sources, Zhu and Li were close colleagues, and together their maps had a profound effect on East Asian cartography. Although neither of their original productions is extant, versions of each exist.

The only extant version of the *Shengjiao guangbei tu* is a Korean work, the *Honil kangni yoktae kukto chi to* (Map of the Integrated Regions and Capitals of States over Time; 1402), often abbreviated *Kangnido* (Map of [Integrated] Regions). This large and lavishly coloured map—an amalgamation of the *Shengjiao guangbei tu* and a fourteenth-century work by Quan Jin titled *Hunyi jiangli tu* (Map of

疆理圖

the Integrated Regions [of China]—not only inspired sub-
sequent Korean versions and a Ming dynasty equivalent,
the *Da Ming hunyi tu* (Integrated Map of the Great Ming
Dynasty; c. 1585); it also became a source of inspiration
for a genre of popular Korean maps known generically as
Ch'onhado (Maps of All Under Heaven). The distinctive
feature of these widely distributed 'wheel maps', in addi-
tion to the cartographic and cultural centrality of China,
is the large number of place-names for 'countries' obvi-
ously derived from Chinese sources, including the *Shanhai
jing*, the Confucian classics, official histories, and some
Daoist works (Fig. 3.4).

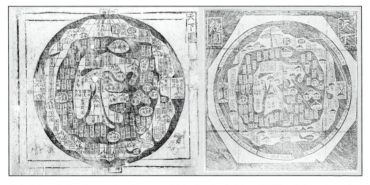

3.4 Two 'wheel maps': a Korean *Ch'onhado* (left), c. 1760, with an inscrip-
tion in Chinese reading 'A map of All Under Heaven', and a Chinese
'wheel map' from the 1760s with an inscription reading 'General Map of
All under Heaven'. The undated Chinese map is a close but not identi-
cal version of the *Ch'onhado*, with most of its place-names and general
configurations the same. Both maps are reproduced with permission from
the Geography and Map Division, Library of Congress.

The preface to the *Kangnido* reveals that Li Zemin's orig-
inal *Shengjiao guangbei tu* failed to include Japan, and that
it did not do justice to the size of Korea. The compiler, Yi
Hoe, therefore added Japan (placed directly opposite the
coast of southern China) and amplified Korea significantly.

30

In fact, the three extant versions of the *Kangnido* show Korea to be at least one-third the size of China. China itself appears as part of a larger general land mass which includes India, while Europe hovers over a small, triangular, south-pointing Africa, with the Mediterranean Sea, at least as large as the African continent, depicted as an inland sea. (At this time, European and Arabic maps represented the tip of the continent as pointing eastward.) Most place names on the *Kangnido*, including about one hundred for Europe and thirty-five for Africa, accord with those of the *Yutu*, suggesting a probable connection between the works of Zhu Siben and Li Zemin.

The only extant version of Zhu's *Yutu* is Luo Hongxian's *Guang Yutu* (Enlargement of the Terrestrial Map; 1579) (Fig. 3.5). In creating it, Luo drew upon many maps, including not only the *Yutu* but also the *Shengjiao guangbei tu* and a number of other Yuan dynasty works. He also con-

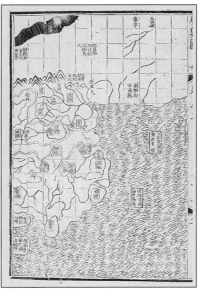

3.5 A section of the *Guang Yutu*, in which China is surrounded by various tributary states, including Korea (near the water on the north-east), Japan (represented by a square cartouche, to the east, at mid-page), the Liuqiu Islands (also in a square cartouche, below Japan), Annam (next to the water on the south-west portion of the mainland), and other South-East Asian states. Reproduced with permission from the collection of the Oriental and India Office, British Library.

sulted several illustrated Ming sources, including various studies of the 'barbarians of the south-western seas'. Like the *Yutu*, the *Guang Yutu* employs a grid, each square purporting to represent 100 *li*, or about 33 miles. But unlike Zhu's map (and, as far as we know, all other Chinese maps up to that time), it includes legends—twenty-four in all—for mountains, rivers, boundaries, roads, and other landmarks.

There are other differences. Whereas Zhu's map was in the form of one long scroll, Luo's consists of a number of individual sheets: one for a 'general map', forty for various provinces, border regions, and waterways, and four for maps of Korea, Mongolia, Annam, and the 'Western Regions'. Moreover, Luo's map obviously reflects, at least in its abundant written texts, the expansion of Chinese knowledge about the rest of the world gained in the course of Zheng He's seven naval expeditions. It also includes a chart that distinguishes the residents of over 120 foreign countries by area: Eastern Barbarians (Koreans and Japanese), South-Eastern Barbarians (Liuqiu Islanders), Southern Barbarians (South-East Asians), South-Western Barbarians (Filipinos, Indians, Westerners, and others), Barbarians of the 'Western Regions' (including various Turkic peoples), and North-Western Barbarians (Mongols and other such tribes).

Although it is impossible to know how closely Luo Hongxian's map approximated that of Zhu Siben, we can certainly see that Luo's work inspired a number of direct imitators. For instance, a two-volume work titled *Da Ming Guangyu kao* (Examination of the Enlarged Terrestrial [Map] of the Great Ming Dynasty; 1610) contains a hand-drawn and lightly coloured 'general map' (*Yudi zongtu*) with grids that correspond closely to those of the *Guang Yu tu* (Plate 1). On the other hand, it is well to bear in mind that most Chinese maps of large territories continued to follow

the *Huayi tu* model.

Although both Zhu and Luo had access to maps and narratives describing India, Africa, and Europe, they appear to have been reluctant to chart the furthest reaches of the known world. Luo's principal concession to Europe on his general map, for example, is a textual note that reads: 'The countries from the Western Ocean that bring tribute...[to China] number forty-nine.' Perhaps the reticence of Zhu and Luo can be attributed simply to Sinocentrism—the long-standing sense that China *was* the world. But Zhu's preface to the *Yutu*, included in the *Guang Yutu*, suggests that he was also wary of depicting areas too far from home for fear of being misled by unreliable information. He tells us: 'Regarding the foreign countries of the barbarians southeast of the South Sea and north-west of Mongolia, there is no means of investigating them because of their great distance, although they are continually sending tribute to the court. Those who speak of them are unable to say anything definite, while those who say something definite cannot be trusted.'

The navigators who charted China's maritime explorations in the Ming period had no such reservations. Working from direct experience, in a cartographic tradition very different from that of Zhu and Luo, they created detailed sailing charts designed solely for practical use. These maps would have had very little value to cartographers using grids, since their highly schematic format of long, sectioned 'strips' involved all kinds of angular, linear, and directional distortions. The scale and orientation of the charts varied from section to section, and even varied within a single section. At the same time, however, accurate sailing instructions regarding distance and direction could always be found in the form of clearly written textual notes.

A late Ming work by Mao Yuanyi, titled *Wubei zhi*

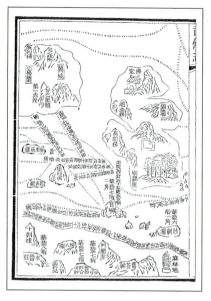

3.6 A section of the *Wubei zhi* showing India (upper left), the island of Ceylon (to the right), the Maldive Islands (below both), and a part of the east coast of Africa. All four locations show 'north' in a different direction, and all have different scales of distance. The scale that applies to Africa is more twice that of India and about five times that of Ceylon.

(Treatise on Military Preparations; *c.* 1621), contains an especially striking sailing chart of the sort described above. Divided into forty rectangular sheets, each about eight inches tall, the chart depicts one of Zheng He's voyages from the Ming capital at Nanjing to the East African coast. We do not know exactly when the nearly twenty-foot long map was actually compiled, but it appears to have been based on records left by Zheng himself. In all, it boasts nearly 500 place names, about 85 per cent of which can be identified with reasonable certainty (Fig. 3.6).

Joseph Needham argues that there was a general 'advance' in Chinese mathematical cartography from the Song period into the seventeenth century. In fact, however, the evolution of map-making in China cannot be characterized as simply a linear process of 'progressive' improvement. Rather, Chinese cartographers continued to produce two types of

34

maps—one based on relatively precise mathematical measurements and one based primarily on general 'information'—without explicitly recognizing the existence of two competing or even different traditions. If a characterization is required, it would have to be that maps of the latter sort greatly outnumbered those based on more mathematical models, not only up to the seventeenth century but into the nineteenth century as well.

Chinese Maps as Cosmographs

Paralleling the development of purely secular maps in China was a long tradition of cosmological cartography. Whereas the Renaissance effectively broke the link between metaphysics and map-making in the West, the connection continued in China—at least in some circles—throughout the imperial era.

On the whole, explicitly religious maps seem to have been less popular in China proper than in other parts of Asia, most notably Burma, Korea, Japan, and Tibet. Indian Buddhism did, however, play a role in Chinese cartography by contributing the idea of a huge continent, known in Sanskrit as Jambūdvīpa (in Chinese, Nanshanbuzhou), which dominated the entire physical world. Only a few early examples of this sort of India-oriented map are extant outside of Korea and Japan, but a 'sinicized' version can be found in Zhang Huang's famous *Tushu bian* (Compilation of Illustrations and Writings; 1613).

This map, the *Sihai Huayi zongtu* (General Map of Chinese and Barbarian [Lands] within the Four Seas), purports to show Jambūdvīpa, but replaces India as the principal geographical focus with China (Fig. 3.7). The Chinese landscape, with its provinces, major rivers, mountains, and the

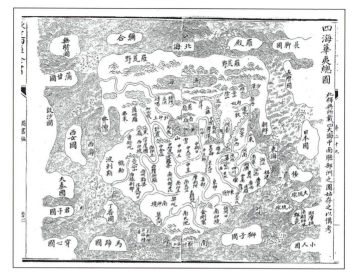

3.7 The *Sihai Huayi zongtu* showing, in addition to the major countries of China's tributary system, a number of places from the *Shanhai jing*: the Land of Long-legged People, the Land of Long-armed People, the Land of Small People, and so forth. Not all of these places are located where the *Shanhai jing* would indicate, however. From Zhang Huang, *Tushu bian* (Compilation of Illustrations and Writings; 1613), in Wang Yunwu, ed., *Siku quanshu* (Complete Library of the Four Treasuries; 1974 reprint), vol. 250.

Great Wall, is depicted in considerable detail; India recedes to comparative insignificance in the south-west. Japan appears as a large, amorphous island far to the east of China. A distinctive feature of this map is its strong affinity with Korean 'wheel maps', not least with respect to the presence of a number of place-names derived from the *Shanhai jing*.

Far more common than these religiously grounded and externally inspired maps were indigenous depictions of the cosmological relationship perceived by the Chinese between earthly forms and heavenly images. This pervasive idea of

physical and metaphysical correlations, derived from the hallowed *Yijing* (Classic of Changes), had many manifestations in traditional China. One of the most widespread was the theory of *fenye* (field allocation). According to this 分野 tenaciously held world-view, each major geographical area of China had a corresponding celestial 'field' in which astronomical events served as portents for earthly administrators. As the Han scholar Zhang Heng put the matter: '[Heavenly bodies] are scattered in confused arrangement, but every one of them has its own distant connections. ...The movements of the sun and the moon reveal signs of good and evil, while the five planets and the [twenty-eight star-based] lunar lodges [*xiu*] forebode fortune and misfortune.'

From the Han dynasty onward, imperial regimes took seriously this correlative cosmology. Officials on the Board of Astronomy carefully recorded celestial events in each sector of the sky, interpreting their significance as auspicious or inauspicious omens for the corresponding terrestrial sector. Over time, a number of different *fenye* systems arose, most based on divisions of the sky marked by the twenty-eight lunar lodges. Thus, for example, the ancient feudal state known as Yan (in the vicinity of present-day Beijing) came to be correlated with the lunar lodges Wei ('Tail') and Ji ('Winnower') in one system, and Dou ('Dipper') and Niu ('Ox') in another. Characteristically, these systems existed side by side, employed selectively as circumstances seemed to warrant.

During the Ming and Qing periods, officially commissioned tracts and private studies, as well as popular almanacs and encyclopaedias, often included maps and other diagrams depicting the relationship between Heaven and Earth. Figure 3.8, from the *Xinzeng xiangji beiyao tongshu* (Newly Amplified Essential Almanac of Auspicious Images; 1721),

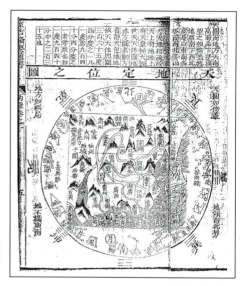

3.8 A 'world map' from the *Xinzeng xiangji beiyao tongshu*.

shows one such illustration: a 'world map', in which virtually all of the major elements of traditional Chinese correlative cosmology appear.

The heavens are described as 'round, like a canopy', while the earth is described as 'square, like a chessboard'. The character for sun appears in a circle at the top of the map ('north') and the character for moon, also enclosed within a circle, appears at the bottom ('south'). The 'eight directions' are indicated by three-line 'trigrams' from the *Yijing*, while the principal stars of each of the twenty-eight lunar lodges appear as small circles linked by thin lines. In the terrestrial portion of the map, China clearly predominates, but Korea, Japan, the Liuqiu Islands, and various states of South-East Asia are also depicted, as is the legendary mountain known as Kunlun. References to other foreign peoples appear in only a few places, designated by terms such as the 'red barbarians' and 'the hundred barbarians'.

Another example of the effort to combine cosmology and cartography can be found in a beautifully executed mid-Qing work known as the *Sancai yiguan tu* (The Three Powers [Heaven, Earth, and Man] Unification Map; 1722). This large scroll, over six feet long and about three feet wide, is divided into several major sections that deal not only with the realms of cosmology and geography, but also with such topics as history, morality, and even military affairs.

The top portion of the scroll consists of various traditional Chinese depictions of the land and sky, including two red planispheres and a 'comprehensive map of Heaven and Earth' in the middle (Plate 2). On the upper left side of the scroll is a 'perpetual map of the unified Qing empire', embracing 'all under Heaven' (Plate 3). On the right side, in a corresponding position, is a chart of all China's emperors from earliest antiquity up to the Ming dynasty. Below these, near the middle portion of the scroll, are four cosmological diagrams derived from the *Yijing*: the Yellow River Chart (*Hetu*), the Luo River Writing (*Luoshu*), and the two main configurations of the eight trigrams. The bottom third or so of the scroll consists of a great many moral admonitions highlighted by famous phrases from the 'Great Learning' (*Daxue*) chapter of the *Liji*. As if to underscore the link between metaphysics and morality, this section is decorated with the *Taiji tu* (Diagram of the Supreme Ultimate), which reflects the balanced cosmic forces of *yin* and *yang*.

The most widespread application of correspondence theory to geographical space in traditional China was the nearly universal practice of 'siting' (*kanyu, fengshui*, etc.), known more commonly as 'geomancy'. The purpose of this hoary art was to locate physical structures for both the living and the dead in places where heavenly and earthly

堪輿 or 風水

configurations—and thus the cosmic currents (*qi*) of *yin* and *yang*—were in harmonious conjunction. The physical space might be as small as a single room, or as large as China itself. Thus, in geomantic manuals one can find prescriptions for the proper placement of furniture, as well as geomantic depictions of the entire Qing empire.

Figure 3.9 shows one common conception of the Middle Kingdom as a 'three-part dragon' of auspicious geographical space, separated by the Yellow and Yangzi rivers. The

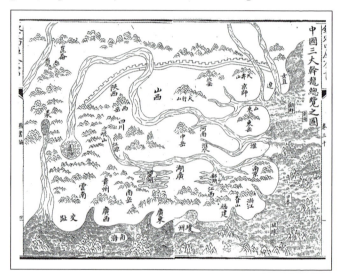

3.9 A geomatically inspired map of the empire, with Korea represented by a rectangular island opposite the Shantong peninsula and Japan by a rectangular island opposite Zhejiang province in south China. From Zhang Huang, *Tushu bian*, in Wang Yunwu, ed., *Siku quanshu*, vol. 250.

'blood' (that is, *qi*) of this tripartite body flows through subsidiary 'trunks and branches' into various rivers and mountains, literally animating the landscape. Maps of this sort can be found not only in geomantic manuals and

scholarly compilations, but also in Ming and Qing ency-
clopaedias such as the *Sancai tuhui* and the *Wanbao quan-
shu*. Smaller geomantic maps, which also employ dragon
imagery and other common symbolic elements in their
depiction of auspicious sites, reflect what Hong Key Yoon
refers to as 'a long and uniform' cartographic tradition with
a high degree of representational refinement.

As with *fenye* conceptions, geomancy sometimes influ-
enced more conventional cartography. For instance, Chinese
map-makers were not above adding topographical features
such as hills or mountains to their cartographic produc-
tions in order to depict (or create) a more favourable geo-
mantic environment. Similarly, where hills and mountains
already existed but were separated by flat expanses that
seemed to diminish their collective power, map-makers
might edit their rendering of the scene to give it greater
geomantic power. Sometimes places would simply be relo-
cated in maps to give them a more favourable geomantic
position.

Of course, correlative cosmology of this sort had its schol-
arly critics. During the late Ming and early Qing periods
in particular, advocates of a new approach to Confucian
learning known as *kaozheng xue* (evidential research)
launched a series of vigorous attacks on geomancy, *fenye*,
and other 'artificial' renderings of geographical space. Their
aim was to 'purify' what they believed to be a corrupt, yet
still state-supported, form of neo-Confucian orthodoxy. In
the realm of cartography, they argued for the creation of
'realistic' maps and the abandonment of 'misleading' cos-
mographs of the sort described above. In this crusade they
received support from newly arrived Jesuit missionaries,
who also sought, for their own reasons, to undermine ele-
ments of the traditional Chinese world-view.

4

China's Initial Encounter with Western Cartography

MANY MODERN SCHOLARS, both Chinese and Western, have seen the arrival of the Jesuits in China during the late sixteenth century as a landmark in the history of Chinese map-making. Benjamin Elman tells us, for example, that their mapping techniques 'stimulated the emergence of scientific cartography in…seventeenth century [China]'. Similarly, Joseph Needham writes that the great contributions of the Jesuits catapulted China 'ahead of all other countries of the world in map-making' by the eighteenth century. Lu Liangzhi identifies the Kangxi and Qianlong eras as marking a new and especially impressive level in the history of Chinese cartography. In fact, however, most of the changes the Jesuits introduced were of relatively short duration. As in the past, when the Chinese had drawn upon Indic, Islamic, or Korean cartographic influences, the knowledge they gained had limited long-term significance.

Jesuit Contributions to Chinese Cartography

There can be no doubt that the Jesuits played an important role in introducing new cartographic techniques to China—just as they contributed significantly to the advancement of astronomical, calendrical, and mathematical knowledge in the Middle Kingdom. The pioneer in this enterprise was, of course, Father Matteo Ricci, who arrived in China in 1582 and immediately began learning the Chinese language. Blessed with a prodigious memory and

driven by a fervent desire to bring Western learning (including, of course, Christianity) to China, Ricci quickly made a number of Chinese friends (and converts) among local scholars and officials in the southern city of Zhaoqing. Their curiosity about his European homeland and the various countries he had passed through in his travels prompted Ricci to produce a European-style map of the world and several small globes, which he presented to these friends as gifts.

Ricci's first map, put together from both Western and Chinese sources (notably Luo Hongxian's *Guang Yutu*), was known initially as the *Yudi shanhai quantu* (Complete Map of the Earth's Mountains and Seas; 1584. Neither the original nor its immediate successor (published in 1600) is extant, but a version of the first map can be found in Zhang Huang's *Tushu bian* of 1613 (Fig. 4.1). Judging from Zhang's

4.1 A version of the *Yudi shanhai quantu*, from Zhang Huang, *Tushu bian*, in Wang Yunwu, ed., *Siku quanshu*, vol. 250.

43

rendering, Ricci's initial map was based on a projection of the world developed by the sixteenth-century European cartographer Abraham Ortelius. Its centre lies somewhere in the Pacific Ocean. China, comprising two large islands as well as a portion of the larger Asian continent, appears just to the left of this mid-point.

The third edition of Ricci's map—twelve feet long, six feet high, and designed to be mounted on a six-part folding screen—involved substantial changes. In this version, which he titled *Kunyu wanguo quantu* (A Complete Map of the Myriad Countries of the World; 1602), Ricci rendered geographical space in a more mathematically accurate way, so that the entire Chinese empire was included as part of the Asian continent (Fig. 4.2). According to Father

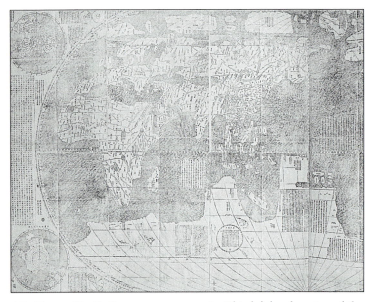

4.2 Matteo Ricci's *Kunyu wanguo quantu*. This left-hand portion of the map depicts Europe, Africa, and Asia. Reproduced with permission from the Oriental and India Office, British Library.

Ricci and several of his Western contemporaries, <u>most of the Chinese scholars who saw this map were utterly transfixed by it. We are told that everywhere Ricci went, Chinese officials asked to make stone etchings or woodblock copies of it, so that they could give rubbings or prints to their friends as gifts.</u> One of Ricci's closest and highest-ranking Chinese associates, Li Zhizao, distributed several thousand copies of the *Kunyu wanguo quantu*, one of which found its way <u>to the Wanli Emperor himself in 1608</u>. Apparently the Emperor was so impressed that he ordered twelve more copies to be made.

Meanwhile, Ricci's maps had begun to influence late Ming scholarship. As early as 1593, an educational official by the name of Liang Zhou put together his *Qiankun wanguo quantu gujin renwu shiji* (Universal Map of the Myriad Countries of the World, with Traces of Human Events, Past and Present) 'after seeing the drawings of Ricci...and the six scrolls engraved by some gentlemen in Nanjing' (see Fig. 4.7 below). Soon thereafter, Wang Qi reproduced a version of Ricci's map in his *Sancai tuhui* of 1607 (see Fig. 4.8 below). A few years later, Cheng Boer and his scholarly associates published renditions of Ricci's eastern and western hemispheres, together with the Jesuit father's written explanations of these maps and a six-part supplement on the *waiyi* ('outer barbarians'), in their *Fangyu shenglüe* (Compendium on Geography; 1612). The *Fangyu shenglüe*, in turn, provided maps of the two hemispheres for Pan Guangzu's *Yutu beikao* (Complete Examination of Maps; c. 1630).

Ricci enjoyed his cartographic celebrity and took particular pleasure in the thought that he was the first person to introduce concrete illustrations of the sphericity of the earth to China. In fact, ancient Chinese records tell of a Persian astronomer who presented Khubilai Khan with a

terrestrial globe (or perhaps a drawing of it) as early as 1267, but few if any of Ricci's Chinese colleagues were aware of this precedent. For virtually all of them, the learned Jesuit's maps and globes presented a startlingly new picture of the world. The fact that this picture contained the erroneous pre-Copernican notion that the sun revolved around the earth was of no particular consequence.

One of Ricci's most striking demonstrations was how meridians could be used to determine precise geographical locations. He explained:

[Ideally] there should be one line for every degree of longitude and latitude, but in...[this particular map] we shall use one line for every ten degrees to avoid confusion. By this method we can place every country in its correct position. ...If two places are equidistant from the equator, but one is south and the other north, then the climate and the length of the day and night in those places will be the same, but the seasons will be reversed, for what is summer in one place will be winter in the other. The greater the distance from the equator, the more marked will be the inequality between the length of the day and night in summer and winter.

In addition to clarifying matters of climate and location, Ricci also transliterated a great many non-Chinese place-names into Chinese. Previous cartographers, geographers, and historians had, of course, done this sort of work before, and Ricci himself borrowed certain Chinese renderings of foreign names in order to identify areas on the periphery of China. But when it came to coining names for more distant places, Ricci found that he could muster enormous authority since he had recently arrived from the furthest Western reaches depicted on the map, and had seen many other parts of the world besides. As Kenneth Chen has demonstrated, many of the place-names rendered by Ricci

on his *mappa mundi* continue to be used in Chinese cartography today.

Ricci recognized the need to make certain cultural concessions to the Chinese in the course of introducing to them radically new geographical and scientific knowledge. Thus, for example, the preface of the *Kunyu wanguo quantu* emphasizes that Ricci came from the West 'filled with admiration for the great Chinese empire, whose fame extends over ten thousand *li*'. In deference to the Sinocentric notion of China's cultural and geographical centrality, Ricci modified the Ortelius projection of his map to place China closer to the middle. He also drew upon the ancient Chinese *huntian* theory, describing the earth as a yolk surrounded by the white of an egg, in order to explain his Ptolemaic conception of the universe. And, 'in keeping with the Chinese genius [for commentary]', he provided abundant textual annotations to his map, including references to places that offered tribute to China.

Ricci's annotations, like the *mappa mundi* itself, were derived from both Chinese and Western sources. Some discuss astronomy, cosmography, and related subjects, while others provide notes on the distinctive products and customs of various areas and countries of the world. Religious propaganda does not figure prominently in the annotations, aside from a brief paragraph in the preface devoted to a discussion of God's greatness and his 'control' over Heaven and Earth. Commentaries written by Ricci's Chinese colleagues on various editions of the *Kunyu wanguo quantu* praise him for his scientific knowledge and moral rectitude, and at least one commends him for helping 'to enhance the size and extent of our imperial maps'.

The descriptions of products and customs in the *Kunyu wanguo quantu* differ in length as well as accuracy, and there seems to be no general principle determining con-

Most countries, European as well as Asian and African, merit at most a few sentences. Of England, we learn only that it 'has no poisonous snakes or other kinds of insects', and even Ricci's home country of Italy receives only the following brief notice: 'In this country there is a pope who is celibate and lives in Rome to perform his duties as head of the Catholic religion. All European countries revere him.'

Ricci's description of Japan is at least four times as long as the one for Italy. In it, he remarks on the 'strong', 'harsh', and 'warlike' nature of the Japanese people and briefly describes their products, tastes, and feudal system of government. Korea receives less attention, although the text pointedly remarks that 'it is the most important tributary country of China'. The description for the Middle Kingdom (literally, 'Country of the Great Ming Dynasty') reads simply: 'China is most famous for its culture and products. It occupies an area which extends from 15 degrees to 42 degrees north latitude, and its tributary countries are numerous. This map contains only [the major] mountains, rivers, provinces, and circuits. For details, various gazetteers may be consulted.'

Several of Ricci's descriptions of countries are derived from Asian and/or European mythology. Thus, in addition to accounts of actual territories, he supplies information on the 'Land of Dwarfs' (Woren guo, not to be confused with the 'Land of Small People', Xiaoren guo, of the *Shanhai jing*), where 'the men and women are only a foot tall. At five they bear children, and at eight they become old. They are often eaten by cranes and so they live in caves to avoid them'. In the 'Land of Spirits' the inhabitants are said to 'wear deerskin for clothing. Their eyes, ears, and nose are like those of human beings, but their mouth is on the neck. They live on deer and snakes'. The 'Ox-hoof Turks', as their name suggests, 'have human bodies and oxen feet';

48

Ricci also blends fact + fiction!

the 'Land of Women', although formerly a place inhabited only by females, 'now has [some] males'.

Some of Ricci's material is drawn almost verbatim from Chinese sources—in particular, Ma Duanlin's famous thirteenth-century *Wenxian tongkao* (Comprehensive Examination of Source Materials). A few places, notably the 'Land of the One-eyed People', seem to have come directly from the *Shanhai jing*. Yet, despite Ricci's use of Chinese material and his other concessions to Chinese culture, <u>the Jesuit father still received harsh criticism from a number of conservative Ming scholars</u>.

One famous critic, Wei Jun, accused Ricci of 'using false teachings to delude people'. According to Wei, Ricci's ✳ so-called world map not only contained 'fabulous and mysterious' information that could not be verified, but in locating China to the west of centre and inclined to the north, it dislodged the Middle Kingdom from its rightful position at 'the centre of the world'. How, Wei asked, 'can China be treated like a small unimportant country?' She Que, another of Ricci's hostile contemporaries, claimed that the idea of a far-away Great Western Ocean realm (Europe) was a complete fiction, designed to obscure the fact that Westerners actually lived close to China (adjacent to the provinces of Fujian and Guangdong, he believed) and were thus an immediate military threat.

Ricci's Successors

Undaunted, and perhaps even spurred on by such criticisms, Ricci's Jesuit successsors perservered in their efforts to bring new cartographic knowledge to China. In 1623, *globe* thirteen years after Ricci's death, Nicolo Longobardi and another China-based Jesuit, Manuel Diaz, produced a

✳ conservative backlash

1623

magnificent <u>lacquered wooden globe</u>, two feet in diameter and illustrated with sea monsters and Western sailing ships. It shared virtually all of Ricci's legends and toponomy, but updated the *Kunyu wanguo quantu* in certain respects, taking into account recent geographical discoveries by Europeans in various parts of the world. It also continued Ricci's relentless assault on the deeply embedded Chinese notion of a flat earth (Plate 4). A long statement by Longobardi and Diaz, inscribed directly on the globe's surface, affirms the earth's sphericity by reference to both geographical exploration and scientific investigation.

Within months of the completion of the Longobardi–Diaz globe, Father Giulio Aleni, a harsh and persistent critic of traditional Chinese *fenye* theory, published his *Zhifang waiji* (Notes on [World] Geography; 1623). This long, scholarly work contained a simplified but mathematically more precise version of Ricci's world map, together with a number of individual maps depicting various limited regions of the earth and two views of the globe, one from each of the north and south poles (Fig. 4.3). It also supplied a different type of commentary from those discussed above. Whereas the annotations for both Ricci's map and the Longobardi–Diaz globe concerned technical, cultural, and historical matters, and appeared directly on the surface of the cartographic image, Aleni's extensive comments were somewhat more philosophical and were written as part of a separate text, in the fashion of Luo Hongxian's *Guang Yutu*.

1600s

☆

In the next few decades, Jesuit scholars produced a number of other world maps, some designed for a Chinese audience and some intended for the West (where estimates of China's size, even by reputable cartographers, still ranged widely, from approximately the area of Europe to four times as large)(Plate 5). Meanwhile, this new knowledge of the world, as in Ricci's time, seeped into various Chinese

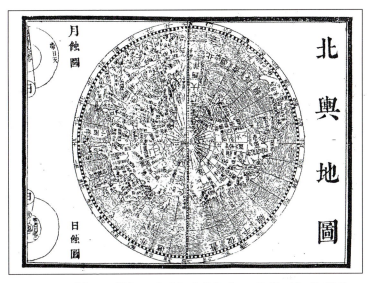

4.3 A view of the world from the North Pole, from Guilio Aleni's *Zhifang Waiji*.

publications, such as the *Gezhi cao* (Scientific Sketches; 1648) by a scholar named Xiong Mingyu. Xiong's fascinating work contains a rather decorative version of the *Kunyu wanguo quantu* as well as a far more general map titled 'The Round Earth Certainly Has No Square Corners' (Fig. 4.4). The accompanying text explains that a ship travelling either east or west can return to its home port by circumnavigating the globe.

In 1674, thirty years after the founding of the Qing dynasty, Father Ferdinand Verbiest produced an expanded edition of Aleni's geographical work, which he called the *Kunyu tushuo* (Illustrated Discussion of the Geography of the Earth). In it, Verbiest included a comprehensive map of the world (*Kunyu wanguo quantu*) consisting of the two hemispheres, each approximately five feet in diameter

51

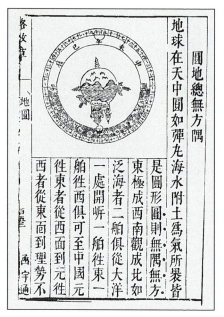

4.4 Map titled 'The Round Earth Certainly Has No Square Corners', from Xiong Mingyu's *Gezhi cao*.

(Figs. 4.5 and 4.6). The map has four cartouches containing information about the size, climate, land-forms, customs, and history of various parts of the world, as well as discussions of earthquakes, clouds, eclipses, and other natural phenomena. The text describing the Americas provides a long account of Christopher Columbus's discovery of the New World, in which Verbiest asserts that the Italian adventurer was 'impelled by God' to explore the Pacific Ocean. He also refers in passing to the travels of Amerigo Vespucci and Hernando Cortés.

In the early eighteenth century, from 1708 to 1718, French Jesuits undertook a series of monumental surveys of the Chinese empire and a few tributary states on behalf of the Kangxi Emperor. These efforts, which provided the Qing government with a certain 'scientific' authority that

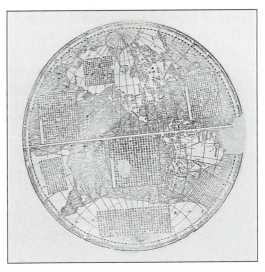

4.5 The western hemisphere, from Ferdinand Verbiest's *Kunyu tushuo*. Reproduced with permission from the Map Room, British Library.

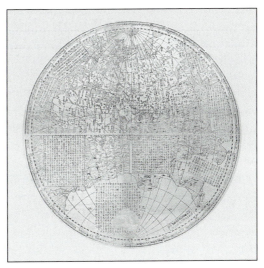

4.6 The eastern hemisphere, from Verbiest's *Kunyu tushuo*. Reproduced with permission from the Map Room, British Library.

bolstered its territorial claims—particularly with regard to peripheral areas of the realm—created a much more mathematically 'accurate' picture of China's lands than had ever been gained before. In fact, these surveys of the vast Manchu-dominated empire and its environs, expressed in various editions of the *Huangyu quanlan tu* (Map of a Comprehensive View of Imperial Territory; first presented to the throne in 1718), remained the primary sources of geographical information on China until the twentieth century. It should be noted, however, that the Jesuits relied heavily on Chinese sources in doing their work.

The Limits to Jesuit Influence

Despite these important contributions to the 'domestic' mapping of China, and notwithstanding the pioneering efforts of Father Ricci and others in charting the larger world during the seventeenth century, Jesuit cartographic influence remained limited in China. One reason was a growing hostility toward Western missionary activity generally—particularly after the so-called Rites Controversy, which resulted in the 1724 banning of Christianity by the Yongzheng Emperor (r. 1723–36). During the eighteenth century, as in Ricci's time, conservative scholars mounted fierce diatribes against Jesuit cartography. The official *Mingshi* (History of the Ming Dynasty; 1739), for example, dismissed Ricci's report of the five continents as 'vague and fictitious'. Similarly, the *Huangchao wenxian tongkao* (The [Qing] Dynasty's Comprehensive Examination of Source Materials), commissioned about the same time, denounced Ricci's account of the world as a 'wild fabulous story' and accused him of belittling China, aggrandizing his own culture, and spreading falsehoods in the course of doing his cartographic work.

Conservative backlash, again. 54

1700s

There were also institutional impediments to the spread of Jesuit cartographic knowledge. David Reynolds argues, for example, that new approaches to learning in the late Ming and early Qing periods (especially the rise of 'evidential research'), and new rhetorical strategies (including the argument that 'Western learning has a Chinese source'), created a certain 'intellectual space' for the practice of science in seventeenth-century China. But he points out that very little 'social space' existed for this sort of activity. Chinese scholars were able to view the maps made by the Jesuits, and some even participated in the process of creating them, but the cartographic techniques used by the missionaries were apparently never taught systematically to the Chinese.

Moreover, despite the 'empirical' emphasis of *kaozheng* scholarship in the late seventeenth and early eighteenth centuries, most Chinese intellectuals drew quite selectively from the available pool of Western scientific knowledge. On the one hand, as John Henderson has argued, a deep distrust of symmetry and regularity on the part of *kaozheng* scholars hostile to traditional cosmography led them to reject the notion of a lawful, uniform, and mathematically predictable universe. On the other hand, a turn inward in Chinese thought after 1644 diverted attention away from Jesuit-style conceptions of the external world.

To be sure, some *kaozheng* scholars, such as Huang Zongxi and Yan Ruoju, ridiculed traditional Chinese *fenye* schemes for failing to take into account foreign lands. 'How can it be', Yan asked, 'that the sun and stars did not look out over the Man, Yi, Rong, and Di [barbarians]?' Yet, Wang Fuzhi, another empirically oriented scholar of the early Qing period, found it possible to reject the round-earth concept of the Jesuits out of hand. And Gu Yanwu, a towering figure in *kaozheng* scholarship, made no mention of

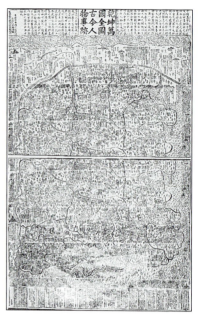

4.7 Liang Zhou's *Qiankun wan-guo quantu gujin renwu shiji*. Reproduced with permission from the Map Room, British Library.

Jesuit world maps in his otherwise comprehensive *Tianxia junguo libing shu* (Treatise on the Advantages and Disadvantages of the Commandaries and States of the Empire; 1662). This lack of a serious interest in the Western world allowed Gu to describe Portugal as simply a one-time tributary state, located 'south of Java', whose early contact with China was for the purpose of studying trade routes and 'buying small children to cook and eat'.

Even individuals who claimed to have been directly inspired by Jesuit world maps often borrowed little of cartographic substance from them. Liang Zhou's *Qiankun wanguo quantu gujin renwu shiji*, for instance, arranges foreign lands topologically rather than topographically (Fig. 4.7). Western locations such as North America (on the upper right-hand side of the map) and South America (on

the lower right-hand side)—like the Land of Big People, the Land of Small People, the Land of Women, and many other places apparently drawn directly from the pages of the *Shanhai jing*—are shown as inconsequential islands surrounding the large nucleus of the Chinese empire.

Wang Qi's version of Ricci's map in the *Sancai tuhui* (Fig. 4.8), although more recognizable than Liang's as a rough copy of the *Yudi shanhai quantu*, is still a pale reflec-

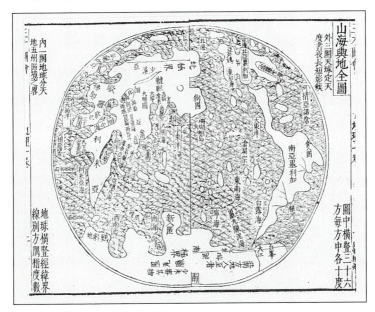

4.8 A version of Ricci's world map from the *Sancai tuhui*.

tion of the original, lacking meridians and including the names of only a few countries. In Europe, only Fulangzhai (presumably France, but often associated with Portugal by the Chinese) is identified, while the descriptive phrase *san-shi yu guo* ('more than thirty countries') appears on the

map as if it were the name of a separate locale. In all of South America we find only one specially designated location: the 'Cannibal Country'. Significantly, the *Sancai tuhui* also includes Song-style maps, such as the *Yuji tu*, which show no influence of Jesuit cartography (Fig. 4.9).

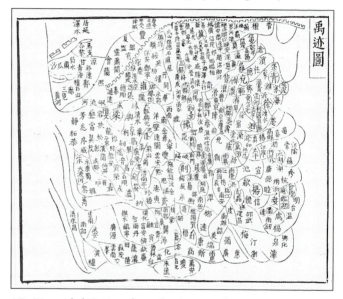

4.9 Map titled *Yuji tu*, from the *Sancai tuhui*.

An undated work titled *Nan Huairen kunyu tushuo* (Verbiest's Illustrated Discussion of the Geography of the Earth), reprinted in a collection of maps known as the *Kangyou jixing* (Records of Travels in Various Directions; no date) provides further evidence of the way foreign cartographic models became transmuted over time (Fig. 4.10). Although the features of Asia, Europe, and Africa bear a vague resemblance to those on Verbiest's map, the shapes of the continents have been softened considerably to resemble traditional Chinese renderings of space. Moreover, the

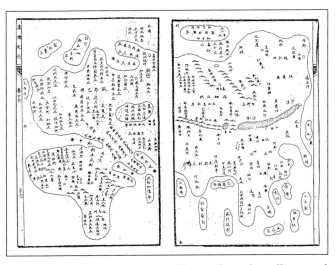

4.10 Permutation of Verbiest's world map, from the collection of maps titled *Kangyou jixing*.

relatively few captions reflect a seemingly random amalgamation of newly introduced Jesuit names and old-style Chinese designations.

From the late seventeenth century into the early nineteenth, the vast majority of Chinese map-makers ignored Jesuit constructions of the world almost entirely. The maps of 1673, 1743, and 1819 depicted in Plates 6 through 14 reflect the cartographic mainstream, a tradition grounded solidly in Song dynasty models such as the *Huayi tu* and traced explicitly in some cases to the sixteenth century 'world map' of Liang Zhou. None of these works, or the countless others like them, show the slightest concern with mathematic accuracy, and all include among the various non-Chinese countries scattered indiscriminately around the periphery of China (usually represented as inconsequential and amorphous islands) a number of mythical lands drawn primarily from the *Shanhai jing*.

5

Cartography and Cultural Change

DURING THE LATE EIGHTEENTH and early nineteenth centuries, Westerners came to China in ever-greater numbers, driven, quite literally, by the powerful engines of the Industrial Revolution. Merchants pursued commercial gain, while missionaries sought converts. Aside from a few centres of residual Catholic activity in north and central China, where a total of about thirty European priests operated, most foreigners were confined to the foreign 'factories' of Guangzhou (Canton) and to the Portuguese outpost at Macao (Aomen) in the south. Despite their relative confinement, many opportunities existed for these foreigners to acquire direct knowledge about China. The Chinese, however, by choice remained largely isolated from the West. It took a series of traumatic conflicts with various foreign sea powers—beginning with the Anglo–Chinese Opium War of 1839–42 and culminating in the disastrous and humiliating Sino–Japanese War of 1894–5—to force a new world-view on the Chinese.

The Early Nineteenth Century

Although the imperialist penetration of China wrought important changes in Chinese cartography, the process took time and proceeded unevenly, not least because the foreign 'impact' came to be felt with varying degrees of force in different parts of China at different historical moments. Although Western gunboats presented a persistent threat to China's security from the late 1830s onward, few Chinese had any idea of their devastating power and aggressive

potential. News of the first Opium War took many years to reach the remote reaches of China's interior provinces, and even in the treaty ports established in coastal (and eventually inland) areas after 1842, the need to acquire knowledge of the world was not always self-evident.

On the eve of the first Anglo–Chinese confrontation, few Chinese had reliable information about the West. We have already seen the confusion displayed in the official Qing account of 'tributary peoples' known as the *Huang Qing zhigong tu*. Other standard Qing sources of information on Westerners, many based on the *Mingshi*, were equally misleading. Moreover, by this time the world maps and cosmopolitan accounts of foreign lands written by the Jesuits were at best a dim memory. On the whole, Song dynasty representations of the physical world dominated both élite and popular consciousness.

1840s...

𝕏

Yet Chinese cartographers never abandoned altogether Western-style interpretations of the world. At least a few map-makers continued to draw upon foreign knowledge— notably the early nineteenth century Daoist priest and scientist Li Mingche, whose *Huantian tushuo* (Illustrations of Encompassing Heaven; 1819) includes two relatively 'modern' illustrations of the eastern and western hemispheres, complete with lines of latitude and longitude (Fig. 5.1). Moreover, we can see in the genre of Ming–Qing maritime maps known as *Haijiang yangjie xingshi quantu* (Complete Map of Coastal Configurations) an obvious awareness of the lands that lay beyond China's sea frontiers.

To be certain, each of these scrolls, nearly thirty feet long and about ten inches wide, conveys most of its cartographic information in a traditional format, unfurling from right (north) to left (south) along the China coast from the southern border of Korea to the northern border of Vietnam.

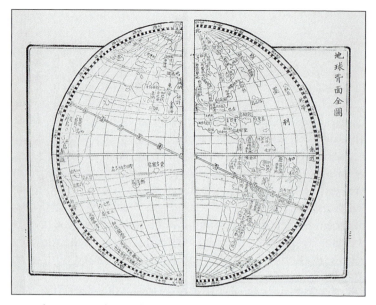

5.1 The western hemisphere, as depicted in Li Mingzhe's *Huantian tushuo*. Reproduced with permission from the Oriental and India Office, British Library.

Mountains and hills are shown in blue, waters are given in green, administrative cities are marked by red squares, and so forth (see Plate 16 below). Scale and perspective vary. Yet each edition also begins with a remarkably Western-looking rendition of the eastern hemisphere, almost assuredly derived from a similar line-drawn map in Chen Lunqiong's *Haiguo wenjian lu* (Record of Things Heard and Seen in the Maritime Countries; 1730). Although the Chinese empire is usually depicted in these introductory maps as being as large as Africa (which we know embraces one-fifth of the earth's total land area), the sailient feature of the map is its unmistakably 'modern' appearance (Plate 15).

After 1842, editions of the *Haijiang yangjie xingshi quantu* began to reflect a new awareness of the Western pres-

ence in treaty port areas—significantly, by means of vague textual remarks indicating that 'during the Daoguang period [1820–50] Western countries [began to] trade at this place' (Plate 16). Such cartographic changes were part of a growing sense among some scholar–officials that China had to acquire more up-to-date information about the maritime world. A pioneer in this intelligence-gathering effort was Commissioner Lin Zexu, an upright and dedicated scholar sent to Canton by the Daoguang Emperor in 1839 to suppress the opium trade. Appalled and dismayed by China's lack of accurate knowledge about the West, Lin sought to improve the situation by organizing a translation bureau staffed by Chinese proficient in Western languages.

The acquisition of information by such individuals in the midst of a foreign war involved significant risks. As one of Commissioner Lin's personal friends pointed out: 'Nowadays, if Chinese are involved in translating foreign books, imitating barbarians' skills, and briefing themselves on the foreign situation...[they] will be punished for committing crimes, causing trouble, and communicating with foreigners.' Yet despite the dangers, Lin's staff not only gathered and translated Western-language materials about the West; they also drew upon Western geographical works written by foreigners in Chinese—tracts produced primarily by missionaries such as Charles Gützlaff and Elijah Bridgman, who preached and proselytized in the Guangzhou–Macao area.

Although this newly acquired information could not alter the unhappy outcome of the Opium War, nor prevent Lin from being cashiered in disgrace and banished temporarily to Chinese Turkestan, it did result in a book, published in the midst of intermittent fighting and negotiation, called the *Sizhou zhi* (Gazetteer of the Four Continents; c. 1841). This work, which Lin circulated privately among scholarly

1841 = 四洲志 — inspired two others of similar ilk

海国图志

colleagues, inspired the publication of two other pioneering works: Wei Yuan's *Haiguo tuzhi* (Illustrated Gazetteer of the Maritime Countries; first published in 1843) and Xu Jiyu's *Yinghuan zhilüe* (A Short Account of the Maritime Circuit; 1849). Of the two, Xu's is focused rather narrowly on geographical detail, while Wei's presents a sweeping geopolitical analysis of Western maritime expansion based on his understanding of the historic importance of the Southern Ocean (Nanyang). What both books had in common was a desire to, in Wei's words, 'describe the West as it appears to Westerners'.

Wei's treatise had a practical orientation. It was designed to show 'how to use barbarians to fight barbarians, how to make the barbarians pacify one another [to our advantage], and how to employ the techniques of the barbarians in order to bring the barbarians under control'. Xu's book, although also motivated by a desire to improve China's strategic position *vis-à-vis* the West, was more in the nature of a scholarly tract. Xu wanted, in other words, to provide a systematic exposition of world geography and to offer a more accurate view of the new and frightening international order that had become increasingly manifest and active in East Asia.

New Ways of World-making

Both the *Haiguo tuzhi* and the *Yinghuan zhilüe* drew upon Chinese as well as Western sources, and both were abundantly illustrated with maps. According to Wei Yuan, about 20 per cent of his material on South-East Asia, South Asia, and West Asia, and about 40 per cent of his information on Russia, Europe, Africa, and the Americas, came directly from Commissioner Lin's *Sizhou zhi*. The remainder

was derived from new sources, including a number of 'barbarian atlases and books published in recent years'. Xu, for his part, also relied heavily on recent Western materials, favoring the 'factual accuracy' of Protestant accounts over the more elegant but excessively 'boastful' and 'crafty' works of the Jesuits. As he put the matter in his preface:

> Westerners like Ricci, Aleni, and Verbiest all lived in the capital [Beijing] for a long time and became well-versed in the Chinese language. Consequently the style of their books is quite clear and agreeable. ...Today's Westerners are not profound [in their use of the Chinese language] and their books are mostly vulgar and inelegant. But the facts related by them of the rise and fall of states are indisputably reliable. So I realize that the elegance of the former cannot replace the sincerity of the latter.

The *Haiguo tuzhi* went through three different editions: the first in 1843, the second in 1847, and the last in 1852. Although Wei's basic geopolitical orientation and his personal writings remained largely unchanged throughout this decade, each edition of his book revealed the acquisition of new information—especially 'maps and geographical materials from the West'. Wei felt that a knowledge of Western geography was necessary but not sufficient, for European expansion had become, in fact, a worldwide phenomenon. The Chinese had to 'comprehend the appearance of the entire globe', he wrote, because 'the English barbarians encircle the world'. About two-thirds of the *Haiguo tuzhi* is thus devoted to world geography.

All three editions of Wei's book begin with a long series of maps. The first two maps depict the eastern and western hemispheres, followed by representations of the principal parts of Asia (including Russia)(Fig. 5.2). Then come individual maps of Africa, Europe, and the Americas, followed by a group of maps indicating 'the political history

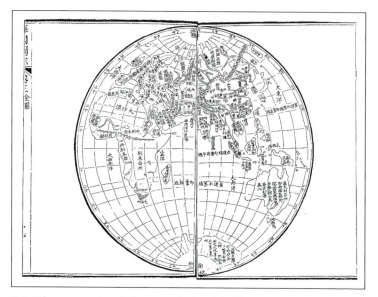

5.2 The eastern hemisphere, as depicted in Wei Yuan's *Haiguo tuzhi*, 1868 edition.

of the major parts of the world'. Wei also supplies historical maps of Central Asia (the 'Western Regions') during the period from the Han through the Tang dynasties, together with a special section devoted to the Yuan dynasty. Next we find maps of certain countries that Wei felt had special significance in Sino–Western relations: Japan, Vietnam, the Spice Islands, England, Russia, and America. This section ends with several maps depicting the entire Chinese coastline.

The maps in the first and second editions of the *Haiguo tuzhi* are identical. Some follow traditional Chinese cartographic principles, while others seem to be more 'Western' in appearance (Fig. 5.3). The third edition of Wei's book reflects a far more substantial use of Western-style maps.

1852:

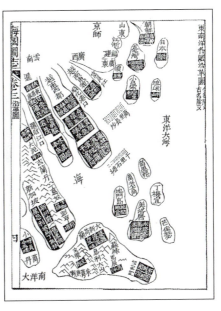

5.3 A traditional Chinese-style map of the 'South-eastern Ocean', from Wei Yuan's *Haiguo tuzhi*. Korea is depicted as an island off the Shandong peninsula, Japan is adjacent to the island of Taiwan and smaller than both it and Korea, and the Liuqiu Islands are parallel with Luzon.

The coverage of the Yuan dynasty is reduced in this edition and there are many more maps of Asia, Africa, Europe, and America. According to Jane Kate Leonard: 'These changes...suggest the growing availability of Western geographical sources and reveal how rapidly the geographical picture of the earth was changing for Chinese like Wei during the decade following the Opium War.'

One of the relatively few Chinese works cited in a bibliographical addendum to Wei's 1852 edition of the *Haiguo tuzhi* is Xu Jiyu's *Yinghuan zhilüe*. In 1844, while working on his scholarly tract, Xu met an American missionary named David Abeel, who introduced him to a number of Western maps of the world. Impressed by their fine detail and 'scientific' accuracy, Xu became convinced that such documents were indispensible to his geographical project. As he explained to his readers:

67

A geography without maps is not clear, but maps not [based on actual] observation are not [accurate] in detail. The world has a form and its protruberances and indentations cannot be conceived [by merely thinking about them]. Westerners are accomplished in travelling to distant places. Their sails and masts encircle the Four Seas. Wherever they go they immediately take out brushes to draw maps. For this reason only they can be relied upon. ...This book uses maps as its guiding principle; these maps have been copied in outline from original maps in the books of Westerners. [In such maps] the veins and arteries of rivers are as fine as hair. Mountain ranges and cities, large and small, are all in place. But since it is impossible to translate all of the names and because the strokes of Chinese characters are so numerous that there is little room to write them on the maps, only the most important rivers and mountain ranges have been included.

Xu's discussion of world geography begins with a general introduction to the planet's physical features, including its shape, land-forms, and bodies of water. Using two hemispherical maps as his points of departure, he explains lattitude and longitude, the path of the sun, and the various climatic zones (Fig. 5.4). Feeling that his readers might not easily accept the idea that the south pole could be as cold as the north pole (which he himself doubted until Abeel assured him it was true), Xu describes an imaginary journey from the south-east coast of China to Borneo, the Cape of Good Hope, and finally to Antarctica—'where the ice never melts'. He goes on to describe the four major continents of Asia, Europe, Africa, and America, criticizing Africa as 'the worst of the four' from the standpoint of weather, soil, and people.

race?

Emphasizing that Asia is the largest continent on earth, Xu locates China in the south-eastern portion, well removed from the centre of the map but comprising 'almost half' of

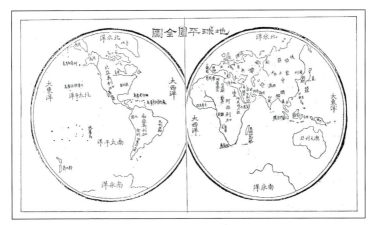

5.4 The western and eastern hemispheres, as depicted in Xu Jiyu's *Yinghuan zhilüe*, 1849 edition.

the vast continent. Significantly, but not surprisingly, he describes China in the most complimentary terms. He claims, for instance, that all things originated in the Middle Kingdom and that all peoples of the world are envious of China. He praises the Qing dynasty for expanding the Chinese empire to an unprecedented extent and identifies a number of countries that regularly send tribute to Beijing. In fact, he asserts, China is so vast and famous that he need not treat it systematically in his geography of the world. A simple map of the 'unified Qing empire'—given pride of place immediately after the two hemispheres—should be, he implies, sufficient to indicate China's greatness.

The remainder of the *Yinghuan zhilüe* is devoted to a detailed discussion of the world beyond China's borders. It begins with the areas and states surrounding the Middle Kingdom (omitting Korea because it is so much 'like China'): Japan and Liuqiu in the east, the states of China's Southern

Ocean, the various countries of South-East Asia, the islands in the South Pacific, India and its environs, Western and Central Asia, Europe, and Russia. It then proceeds to Africa and finally the Americas. Of the forty-two maps in Xu's book, all but one—a depiction of Japan and the Liuqiu Islands—are based on Western sources. For this single exception Xu derived his image from a traditional-style map contained in Chen Lunqiong's *Haiguo wenjian lu*. His reasoning was that because Western traders rarely travelled to Japan, their maps of these island kingdoms were not sufficiently reliable.

Soon after publication of his book, Xu endured a barrage of criticism from conservative Chinese scholars, who accused him of toadying to foreigners, both in his published writings and in his official duties as governor (during the years 1846–51) of Fujian province. Although Wei Yuan also had his critics, the *Haiguo tuzhi* represented an effort to bring Qing practices more fully into line with Ming dynasty traditions rather than to promote a new, Western-oriented conception of China's foreign relations. As a high-profile iconoclast, Xu made an especially easy target.

Nonetheless, a number of Qing scholars recognized Xu's *Yinghuan zhilüe* as a valuable work that 'cleared away incredible statements' and portrayed the world more accurately than had any previous study. Liu Hongao, for example, criticized Wei's *Haiguo tuzhi* for being more than 50 per cent unreliable, and praised Xu's work as 'a guide to the world for a hundred generations'. Similarly, Dong Xun, a leading figure in China's Zongli Yamen (Foreign Office) wrote in 1866, five years after the office was established, that of all the available Chinese geographical works on foreign lands, only Xu's could be trusted.

Maps and Modernization

From the 1860s onward, throughout the course of the country's so-called Self-Strengthening Movement (*c.* 1862–95), ever more Western scientific and technical works, including studies of geography and cartography, became available in China. The establishment of translation bureaus in newly sanctioned Chinese arsenals, shipyards, and other modernizing institutions, together with the growth of both missionary and secular translation activities, brought a heightened awareness of the outside world to Chinese scholars. Particularly influential in this regard were new-style Chinese-language periodicals, such as the *Zhong Xi wenjian lu* (Record of Things Heard and Seen in China and the West), the *Wanguo gongbao* (Globe Magazine), and the *Dianshi zhai huabao* (Illustrated Review of the Dianshi Studio). These new sources of information portrayed the advantages of Western science and technology and also revealed the disruptive influence of foreign activity in China and elsewhere.

In the meantime, having been drawn against its will into a new system of international relations, the Qing government began to send Chinese envoys to the West—first informally (the Binchun and Burlingame missions of the late 1860s), and then, reluctantly, as part of the process of establishing official Chinese legations abroad (beginning in the late 1870s). The diaries and memoirs of these envoys played a significant role in changing Chinese perceptions of the outside world and in further exposing the limitations of traditional scholarship about the West. Zhang Deyi, who began his overseas diplomatic career as a lowly interpreter in 1866 and eventually became China's minister to Great Britain in the early twentieth century, wrote in 1872

that after travelling over thirty thousand miles and visiting thirteen countries he came to realize that 'the pages of the [Chinese] geographers of old...[represent at best] 20 or 30 per cent veracity'.

We should not imagine, however, that traditional Chinese attitudes died a swift death in the face of new knowledge about the rest of the world. In the first place, the Qing court continued to hold tenaciously to its tributary view of foreign relations. Even progressively minded officials such as Xu Jiyu found that they had to employ a standard vocabulary of deprecation toward foreigners in their communications with the throne. Thus, although Xu worked closely with Western collaborators on the *Yinghuan zhilüe* during the 1840s, in his capacity as governor of Fujian he railed hypocritically against the complicity of 'Chinese traitors' with foreigners, while describing barbarians repeatedly with the cliché that their nature was 'like that of dogs and sheep'. For decades thereafter Qing officials did the same.

Moreover, Chinese encyclopaedias—both élite and popular—continued to depict areas and people that simply did not exist. Throughout the nineteenth century, outlandish illustrations from the *Shanhai jing* appeared in various editions of the *Sancai tuhui* as well as the *Wanbao quanshu*. Some of these pictures even found their way into new-style treaty port publications—notably the *Dianshi zhai huabao*, China's late Qing equivalent to the *National Enquirer* in today's United States (Fig. 5.5). Nevertheless, as greater numbers of Westerners and other aliens came to China's shores, and as more and more Chinese went abroad, the Chinese people began to acquire a more 'realistic' sense of foreign features and fashions.

During the last quarter or so of the nineteenth century, study associations, books, and journals devoted to geo-

5.5 Left: Illustration from 'A Xing Yao in Italy', a report in *Dianshi zhai huabao* describing an Italian child 'born with a body but no a head' who resembled the ancient creature known in the *Shanhai jing* as Xing Yao (also rendered Xing Tian). The writer refers specifically to the *Shanhai jing* in his account. Right: Depiction of Xing Yao from a late Qing (1884) edition of the *Shanhai jing*. According to Chinese folklore, Xing Yao was mutilated by the 'Lord on High' for rebelling against him.

graphical issues proliferated in China. The publication of Wang Xiqi's massive *Xiaofanghu zhai yudi congchao* (Collected Texts on Geography from the Small Square Vessel Studio; 1877–97), which brought together several hundred individual Qing dynasty titles, marked a watershed in China's geographical awareness. In the 1890s, the Qing court itself attempted to update and standardize geographic and cartographic practices.

But it was the Sino-Japanese war at mid-decade that sounded the death knell of traditional Chinese cartography. From this time onward, in élite journals and even popular

almanacs and encyclopaedias, Chinese readers sought ever more accurate knowledge about other peoples of the world, including the once-despised Japanese. The rise of Chinese nationalism—generated by China's humiliating defeat at the hands of the *wokou* ('dwarf bandits')—brought a heightened awareness of the wages of foreign imperialism. Chinese cartography, like many other areas of Chinese life after 1895, became suffused with the spirit of patriotism and political action. One revealing illustration can be found in a map contained in a 1912 almanac, issued in the name of the newly established Republic of China. Although cartographically unsophisticated, the map is fascinating for its commentaries, which strikingly identify the various places taken from China by foreign imperialism, including the province of Taiwan and the tributary states of Korea, the Liuqiu Islands, and Annam (Plate 17).

During the twentieth century, particularly after the 1912 fall of the Qing dynasty, Western influences penetrated ever further into China. This was particularly true during the New Culture Movement (c. 1915–25), an iconoclastic assault on traditional Chinese culture and a search for new values and institutions in the midst of warlordism, social unrest, widespread demoralization, and foreign imperialism. The period was marked by a tremendous surge of interest in Western values, especially science and democracy, by experimentation with new artistic, dramatic, and literary forms, and by the development of a new national literature influenced strongly by Western themes and models.

共和國: From this point onward the principles of 'scientific' cartography came to be almost universally accepted in China—at least among intellectual élites and teachers in new-style schools. It is true, however, that old-fashioned maps continued to appear in some popular almanacs and geomantic manuals. Moreover, even 'scientific' maps continued to

reflect certain distinctive Chinese cultural attitudes. Not surprisingly, most Chinese maps of the world—whether produced in the People's Republic or on Taiwan—still depict China near the centre of the projection, although the Chinese are certainly not unique in situating themselves this way (Plate 18). In fact, on the whole modern China's cartographic conceits seem no more remarkable than those of other countries. Even maps of the world designed expressly for the education of children, such as those that appear in the series *Ertong ditu ce* (Maps for Children, 1989), are no more ideological than are their counterparts elsewhere. In fact, this particular book begins by emphasizing the solidarity of all the world's children: white, black, yellow, and brown (Plate 19).

But Chinese nationalism remains a powerful force in all spheres of Chinese life, including cartography. Although not every twentieth-century Chinese map displays the same degree of 'scientific' sophistication, virtually all demonstrate an abiding interest in the accurate depiction of China's political boundaries. This is true not only of world maps, which naturally seek to establish and document Chinese territorial claims (against, for instance, the geographical inroads of foreign imperialism or separatist claims, as in the case of Tibet). It is true as well of the ideological battle between the two major contenders for political legitimacy in China from the 1920s onward: the Guomindang (Nationalist Party) and the Gongchandang (Communist Party). Chinese cartography may not reflect 'culture' or 'art' in the way it once did, but it continues to serve the interests of political leaders on both sides of the Taiwan Straits.

6

Conclusion

IN AN ARTICLE titled 'Deconstructing the Map', the late J. B. Harley describes two seemingly contradictory approaches to cartographic representation: one governed by scientific ('positivistic') principles and assumptions, the other by non-scientific ('cultural') principles and assumptions. In the eyes of most cartographers, the history of map-making reveals a progression during which the former necessarily replaces the latter. From Harley's standpoint, however, all maps are cultural products. 'Cartography', he says, 'has never been an autonomous and hermetic mode of knowledge, nor is it ever above the politics of knowledge.' Thus, he argues, the distinction between 'rhetorical' (culture-bound) and 'non-rhetorical' (scientific) maps is an illusion. One can never read a map, much less evaluate it properly, without reference to its specific cultural purposes.

From this perspective, any attempt to privilege one of the two cartographic traditions over the other becomes meaningless. Even if, for the sake of argument, we grant a Ptolemaic distinction between the 'science' of geography, based on astronomical and mathematical principles, and the 'art' of chorography, based on a general pictorial impression of an area without regard for 'quantitative accuracy', it is obvious that there are many different, but equally 'scientific' ways of depicting space—witness the radical gap between, say, a Mercator projection of the world and one using the principles of Arno Peters.

No map can be completely 'objective'. Comparing the way maps were constructed and used by various culture groups may provide us with valuable insights into different ways of 'world-making', but there is little to be gained

in talking about cartography comparatively in terms of a linear developmental process. For this reason, the continued use and even predominance of traditional-style world maps in China well after the Jesuits introduced their 'scientific' cartography should not be described, as many have done, as a 'backward' step. Nor is there much point in emphasizing, as some have also done, the 'superiority' of Chinese cartography to that of the Europeans until the mid-seventeenth century or so.

China's response to new forms of cartographic knowledge, like the response of non-Chinese peoples to Chinese cartography, has always been a complex historical process, conditioned by factors such as domestic politics, social attitudes (including religious beliefs, cultural pride, and assumptions about foreigners), intellectual trends, international relations (including foreign conquest), and even aesthetic tastes and decorative fashions. In this short book I have been able to touch on only a few of these themes. But, as the case of the Jesuits in East Asia abundantly illustrates, different countries may assimilate the same basic body of new knowledge in significantly different ways, depending on any number of the variables noted above. A close reading of the excellent essays on China, Japan, and Korea in the *History of Cartography* (vol. 2.2) by J. B. Harley and David Woodward confirms this point.

At all events, one thing is evident: Chinese map-makers saw no need to establish a purely mathematical cartography—either before or after the Jesuit interlude—at least not until the twentieth century. To be sure, they understood the utility and appeal of accurate measurement, and they developed sophisticated astronomical instruments that made possible the projections and coordinate systems Westerners associate with Ptolemaic cartography. The *Yuji tu* of 1136 is, by any standard, a masterpiece of premodern mathe-

matical precision. But for most of their history the Chinese saw no special merit in drawing maps to scale. Besides, they knew that written commentaries could always provide precise details, if they should prove necessary.

Chinese depictions of foreigners and foreign lands prior to the twentieth century indicate a clear emphasis on the 'cultural' and 'administrative' functions of maps and other illustrations over their value as 'scientific' documents. The mathematical and astronomical contributions of the Jesuits may have enhanced the repertoire of Chinese cartographers, and even provided new tools for the Manchus to assert territorial claims, but they could not effect a fundamental transformation of consciousness. Nor could the *kaozheng* tradition of 'evidential research'. Despite a long tradition of sophisticated geographical and cartographic scholarship, an equally long history of foreign exploration, and the systematic acquisition of information on barbarians, the 'outer' world remained relatively unimportant to the vast majority of Chinese, élites and commoners alike. Until forced to reconsider their craft by new political and cultural priorities, Chinese map-makers and other illustrators tended to depict the world not so much in terms of how it 'actually' was, but rather in terms of how they wanted it to be.

Throughout the imperial era, written texts remained the principal means of conveying the truth in China, and that truth (or *dao*), remained predominantly a moral one. In contrast to the West during and after the Renaissance, where 'science' and its handmaiden, mathematical representation, increasingly had independent 'value', the Chinese in imperial times never saw things quite that way. Even *kaozheng* scholars—self-conscious exponents of 'solid learning' and the search for 'truth through facts'—remained dedicated primarily to a text-based quest for moral lessons

imbedded in the classics. This necessarily limited both the direction and extent of China's so-called epistemological 'revolution'.

At the risk of over-generalizing, the history of Chinese cartography, like the history of Chinese divination, suggests that although *kaozheng* scholarship succeeded in breaking the lock of neo-Confucian orthodoxy, it took the combined influence of foreign imperialism and Chinese nationalism to open the door to a radical restructuring of Chinese thought and society. To be sure, the complex political, social, and intellectual movements of the late Qing and early Republic cannot be reduced to a simple contrast between imported transformative orientations and stagnant indigenous ones. But the process of change in China was profoundly affected by a belief that modern Western science, technology, and other forms of new knowledge could solve problems in ways that traditional approaches could not. Chinese maps may not have contributed substantially to the transformations that actually took place, but they certainly reflected them.

Glossary

Ch'onhado 天下圖	Map of All Under Heaven
Da Ming Guangyu kao 大明廣輿考	Examination of the Enlarged Terrestrial Map of the Great Ming Dynasty
Da Ming hunyi tu 大明混一圖	Integrated Map of the Great Ming Dynasty
Da Qing yitong tianxia quantu 大清一統天下全圖	The Great Qing Dynasty's Complete Map of All Under Heaven
daoli 道里	'Road measurement' principle of map-making
Daxue	Great Learning
Dianshi zhai huabao 點石齋畫報	Illustrated Review of the Dianshi Studio
Ertong ditu ce 兒童地圖冊	Maps for Children
fangxie 方邪	'Determination of diagonal distance' principle of map-making
Fangyu shenglüe 方輿勝略	Compendium on Geography
Fangzhang tu 方丈圖	One-*zhang*-square Map
fengshui 風水	Geomancy; siting
fenlü 分率	'Proportional measure' principle of map-making
fenye 分野	'Field allocation' cosmological theory
gaitian 蓋天	'Covered heaven' cosmological theory
gaoxia 高下	'Levelling of heights' principle of map-making
Gezhi cao 格致草	Scientific Sketches
Guang Yutu 廣輿圖	Enlargement of the Terrestrial Map
Gujin tushu jicheng 古今圖書集成	Collection of Illustrations and Writings, Ancient and Recent
Haiguo tuzhi 海國圖志	Illustrated Gazetteer of the Maritime Countries
Haiguo wenjian lu 海國聞見錄	Record of Things Seen and Heard in the Maritime Countries
Haijiang yangjie xingshi quantu 海疆洋界形勢全圖	Complete Map of Coastal Configurations
Hainei Huayi tu 海內華夷圖	Map of Chinese and Foreign Lands within the [Four] Seas
Hetu 河圖	'Yellow River Chart'
Honil kangni yoktae kukto chi to 混一疆理歷代國都之圖	Map of the Integrated Regions and Capitals of States over Time
Huang Qing zhigong tu 皇清職貢圖	Illustrations of the Tribute-bearing People of the Qing
Huangchao wenxian tongkao 皇朝文獻通考	The Dynasty's Comprehensive Examination of Source Materials
Huangyu quanlan tu 皇輿全覽圖	Map of a Comprehensive View of Imperial Territory
Huantian tushuo 闔天圖説	Illustrations of Encompassing Heaven

Huayi lieguo rugong tu 華夷列國入貢圖	Illustrations of Sino-foreign Tribute-bearers
Huayi tu 華夷圖	Map of China and the Barbarians
huntian 渾天	'Enveloping heaven' cosmological theory
Hunyi jiangli tu 混一疆理圖	Map of the Integrated Regions
Jiaxiasi chaogong tuzhuan 戛黠斯朝貢圖傳	An Illustrated Account of the Tribute-bearing Kirghiz People
Jiu Tangshu 舊唐書	Old Tang History
Kangnido 疆理圖	Map of [Integrated] Regions
Kangyou jixing 康輶紀行	Record of Travels in Various Directions
kanyu 堪輿	Geomancy; siting
kaozheng xue 考證學	School of Evidental Research
Kunyu quantu 坤輿全圖	Complete Map of the Earth's Geography
Kunyu tushuo 坤輿圖說	Illustrated Discussion of the Geography of the Earth
Kunyu wanguo quantu 坤輿萬國全圖	A Complete Map of the Myriad Countries of the World
Liji 禮記	Record of Ritual
Luoshu 洛書	'Luo River Writing'
Mingshi 明史	History of the Ming Dynasty
Nan Huairen kunyu tushuo 南懷仁坤輿圖說	Verbiest's Illustrated Discussion of the Geography of the Earth
qi 氣	Cosmic currents
Qiankun wanguo quantu gujin renwu shiji 乾坤萬國全圖古今人物事跡	Universal Map of the Myriad Countries of the World, with Traces of Human Events, Past and Present
Qinding Shujing tushuo 欽定書經圖說	Imperially Endorsed Illustrations Based on the Classic of History
Sancai tuhui 三才圖會	Illustrated Compilation of the Three Powers
Sancai yiguan tu 三才一貫圖	The Three Powers Unification Map
Shanhai jing 山海經	Classic of Mountains and Seas
Shengjiao guangbei tu 聲教廣備圖	Map of the Vast Reach of Teaching
Shiji 史記	Historical Records
Shijie ditu 世界地圖	World map
Shujing 書經	Classic of History
Sihai Huayi zongtu 四海華夷總圖	General Map of Chinese and Barbarian Lands within the Four Seas
Sizhou zhi 四洲志	Gazetteer of the Four Continents
Songben lidai dili zhizhang tu 宋本歷代地理指掌圖	Song Dynasty Edition of Handy Geographical Maps, Chronologically Organized
Taiji tu 太極圖	Diagram of the Supreme Ultimate
Tianxia junguo libing shu 天下郡國利病書	Treatise on the Advantages and Disadvantages of the Commandaries and States of the Empire
Tushu bian 圖書編	Compilation of Illustrations and Writings
Wanbao quanshu 萬寶全書	Complete Book of Myriad Treasures
Wanguo gongbao 萬國公報	Globe Magazine

Wanyong zhengzong buqiuren quanbian 萬用正宗不求人全編	The Complete Orthodox 'Ask No Questions' Handbook for General Use
Wenxian tongkao 文獻通考	Comprehensive Examination of Source Materials
Wubei zhi 武備志	Treatise on Military Preparations
Xiaofanghu zhai yudi congchao 小方壺齋輿地叢鈔	Collected Texts on Geography from the Small Square Vessel Studio
Xinzeng Xiangji beiyao tongshu 新增象吉備要通書	Newly Amplified Essential Almanac of Auspicious Images
Xiyu zhuguo fengwu tu 西域諸國風物圖	Illustrations of the Customs and Products of All Countries in the Western Regions
Xuanhe fengshi Gaoli tujing 宣和奉使高麗圖經	An Illustrated Record of an Embassy to Korea in the Xuanhe Period
xuanye 宣夜	'Empty space' cosmological theory
Yijing 易經	Classic of Changes
Yili 儀禮	Etiquette and Ritual
Yinghuan zhilüe 瀛環志略	A Short Account of the Maritime Circuit
Yiyu tuzhi 異域圖志	An Illustrated Gazetteer of Foreign Lands
Yudi shanhai quantu 輿地山海全圖	Complete Map of the Earth's Mountains and Seas
Yudi zongtu 輿地總圖	'General Map'
Yugong 禹貢	'Tribute of Yu'
Yuji tu 禹跡圖	Maps of the Tracks of Yu
Yutu 輿圖	Terrestrial Map
Yutu beikao 輿圖備考	Complete Examination of Maps
yuzhi 迂直	'Straightening curves' principle of map-making
Zhifang waiji 職方外紀	Notes on Geography
zhigong tu 職貢圖	'Illustrations of Tribute-bearing people'
Zhong Xi wenjian lu 中西聞見錄	Record of Things Heard and Seen in China and the West
Zhongguo dili tuji congkao 中國地埋圖籍叢考	Collected Studies of Chinese Geographic Maps and Writings
Zhongguo dili xue shi 中國地理學史	History of Chinese Geography
Zhongguo ditu xue shi 中國地圖學史	History of Chinese Cartography
Zhongguo gudai dili shi 中國古代地理史	History of Ancient Chinese Geography
Zhongguo gudai ditu ji 中國古代地圖集	Collection of Ancient Chinese Maps
Zhonghua minguo yuannian lishu 中華民國元年曆書	Almanac for the First Year of the Republic of China
Zhongwen yutu mulu 中文輿圖目錄	Catalogue of Chinese Maps in the National Library of Beiping
Zhongyong 中庸	Doctrine of the Mean
Zhouli 周禮	Rituals of Zhou
zhunwang 準望	'Regulated view' principle of map-making
Zuozhuan 左傳	Commentary of Zuo

Selected Bibliography

Barnes, Trevor, and James Duncan, eds. (1992), *Writing Worlds: Discourse, Text and Metaphor in the Representation of Landscape*, London and New York: Routledge.

Bernard, Henri, S.J. (1938), 'Les Étapes de la Cartographie Scientifique pour la Chine et les Pays Voisins depuis le XVIe siècle jusqu'a la fin du XVIIIe siècle', *Monumenta Serica*, 3: 428–77.

Bernard-Maitre, H. (1926), *La Mappemonde Ricci du Musée historique de Pékin*, Peiping: Politique de Pékin.

British Library, The (1974), *Chinese and Japanese Maps*, London: The British Library.

Cao Wanru, et. al., eds. (1990), *Zhongguo gudai ditu ji* (Collection of Ancient Chinese Maps), vol. 1, Beijing: Wenwu chubanshe.

Chang, Sen-dou (1974), 'Manuscript Maps in Late Imperial China', *The Canadian Cartographer*, 11(1): 1–14.

Ch'en Kuan-sheng (1939), 'Matteo Ricci's Contribution to, and Influence on, Geographical Knowledge in China', *Journal of the American Oriental Society*, 59: 325–59.

Ch'en Kuan-sheng (1942), 'Hai Lu: Forerunner of Chinese Travel Accounts of Western Countries', *Monumenta Serica*, 7: 208–26.

Chen Feiya, et. al. (1984), *Zhongguo gudai dili shi* (History of Ancient Chinese Geography), Beijing: Kexue chubanshe.

Cheng Hsiao-Chieh, et al., trans. (1985), *Shan Hai Ching: Legendary Geography and Wonders of Ancient China*, Taipei: National Institute for Compilation and Translation.

Chia Ning (1993), 'The Lifanyuan and the Inner Asian Rituals in the Early Qing (1644–1795), *Late Imperial China*, 14(1): 60–92.

Drake, Fred (1975), *China Charts the World: Hsü Chi-yü and His Geography of 1848*, Cambridge, MA: Harvard University Press.

Duyvendak, J. J. L. (1938), 'The Last Dutch Embassy to the Chinese Court (1794–1795)', *T'oung Pao*, 34: 1–116.

Elman, Benjamin (1981–3), 'Geographical Research in the Ming-Ch'ing Period', *Monumenta Serica*, 35: 1–18.

Fuchs, Walter (1946), *The 'Mongol Atlas' of China by Chu Ssu-pen, and the 'Kuang Yü T'u'*, Peiping: Fu Jen University.

Guoli Beiping Tushuguan (1934), *Zhongwen yutu mulu* (Catalogue of Chinese Maps in the National Library of Beijing), Beiping: Guoli Beiping Tushuguan (supplement, 1937).

Harley, J. B., and David Woodward, eds. (1994), *The History of Cartography*, vol. 2, book 2, *Cartography in the Traditional East and Southeast Asian Societies*, Chicago: University of Chicago Press.

Henderson, John (1984), *The Development and Decline of Chinese Cosmology*, New York: Columbia University Press.

Hevia, James L. (1995), *Cherishing Men from Afar: Qing Guest Ritual and the Macartney Embassy of 1793*, Durham and London: Duke University Press.

Hummel, Arthur W. (1940), 'A View of Foreign Countries in the Ming Period', *Annual Reports of the Librarian of Congress*, Washington, DC: Library of Congress, Oriental Division, pp. 165–9.

Hummel, Arthur W. (1933–4), 'Sixteenth Century Geography', *Annual Reports of the Librarian of Congress*, Washington, DC: Library of Congress, Oriental Division, pp. 7–9.

Hummel, Arthur W. (1938), 'The Beginnings of World Geography in China', *Annual Reports of the Librarian of Congress*, Washington, DC: Library of Congress, Oriental Division, pp. 224–9.

Johnstone, Simone, trans. (1992), *Diary of a Chinese Diplomat, Zhang Deyi*, Beijing: Panda Books.

Leonard, Jane Kate (1984), *Wei Yuan and China's Rediscovery of the Maritime World*, Cambridge, MA: Harvard University Press.

Livingstone, David (1988), 'Science, Magic and Religion: A Contextual Reassessment of Geography in the Sixteenth and Seventeenth Centuries', *History of Science*, 26: 269–94.

Lu, Liangzhi (1984), *Zhongguo ditu xue shi* (History of Chinese Cartography), Beijing: Cehui chubanshe.

Needham, Joseph (1954–9), *Science and Civilization in China*, vols. 1–3, Cambridge: Cambridge University Press.

Reynolds, David (1991), 'Redrawing China's Intellectual Map: Images of Science in Nineteenth Century China', *Late Imperial China*, 12(1): 27–61.

Ronin, Charles, and Bonnie Oh, eds. (1988), *East Mets West: The Jesuits in China, 1582–1773*, Chicago: Loyola University Press.

Shanghai guji chubanshe, ed. (1989), *Songben lidai dili zhizhang tu* (A Song Dynasty Edition of Handy Geographical Maps, Chronologically Organized), Shanghai: Shanghai guji chubanshe.

Smith, Richard J. (1994), *China's Cultural Heritage: The Qing Dynasty, 1644–1912*, Boulder, San Francisco, and Oxford: Westview Press.

Smith, Richard J. (1992), *Chinese Almanacs*, Hong Kong: Oxford University Press.

Smith, Richard J. (1991), *Fortune-tellers and Philosophers: Divination in Traditional Chinese Society*, Boulder, San Francisco, and Oxford: Westview Press.

Smith, Richard J. (1975), 'The Employment of Foreign Military Talent: Chinese Tradition and Late Ch'ing Practice', *Journal of the Hong Kong Branch of the Royal Asiatic Society*, 15: 113–38.

Wallis, Helen (1988), 'Chinese Maps and Globes in the British Library and Phillips Collection', in Francis Wood, ed. (1988), pp. 88–95

Wang Yong (1938), *Zhongguo dili tuji congkao* (Collected Studies of Chinese Geographic Maps and Writings), Shanghai: Shangwu yinshu guan.

Wang Yong (1938), *Zhongguo dilixue shi* (History of Geography in China), Shanghai: Shangwu yinshu guan.

Wills, John (1984), *Embassies and Illusions*, Cambridge, MA: Harvard University Press.

Wood, Francis, ed. (1988), *Chinese Studies*, London: The British Library.

Yee, Cordell D. K. (1992), 'A Cartography of Introspection: Chinese Maps as Other Than European', *Asian Art*, 5(4): 29–47.

Yoon Hong Key (1992), 'The Expression of Landforms in Chinese Geomantic Maps', *Cartographic Journal*, 29 (June): 12–15.

Index

Characteristic aspects of traditional Chinese cartography:

- no concern for mathematical accuracy
 (details often added in accompanying text)
- areas drawn w/ roundedness → no angular lines
- "Chinese" cultural center in the center, with other
 areas in periphery → and included seemingly
 at random (some known peoples/countries are
 mapped, some not)

- 圖 from the 山海經 are frequently included
 alongside actual places with no distinction
 between the two. (this practice persisted into the
 late 1600s!)

In the 1600s + 1700s Jesuit cartography made a small
impression, but by the 1800s it was a distant memory
and, on the eve of the Opium Wars, 宋代 conceptions of the world
dominated. (w/ a few noted exceptions)

Opium War — big shift: First genuine interest in the West

1841 Lin Zexu publishes → 四洲志

1843 Wei Yuan publishes → 海国圖志
 - ²/₃ on world geography!!
 - subsequent editions in 1847 + 1852

1849 Xu Jiyu publishes 瀛環志略
 Yinghuan
 - criticizes Africa as the worst of the 4 continents
 - begins w/ maps of the two hemispheres
 (world maps), map
 of 清 empire, then:
 - rest is devoted to the world
 - 41 of his 42 maps were based on Western
 sources (for which he was roundly criticized)

NOTE! He frequently uses the phrase "Chinese cartographers" even though
he notes on p. 2 that they didn't exist as such!

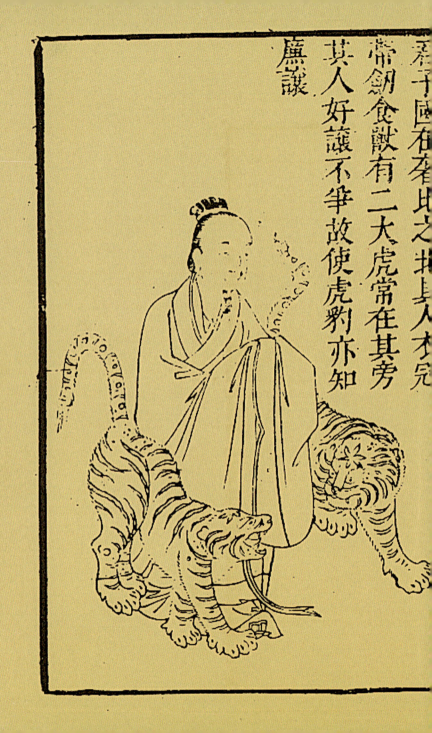

君子國在奢比之北其人衣冠帶劒食獸有二大虎常在其旁其人好讓不爭故使虎豹亦知廉讓